WT

Chris.K

, Keith.

egna, Padua
/

DEC 6 1999

D1172012

EVANSTON · PUBLIC
LIBRARY

*Purchase of this library
material made possible
by a contribution
to the Fund for Excellence*

Barbara B.

and

John H.
Morrison

Andrea Mantegna

Padua and Mantua

EVANSTON PUBLIC LIBRARY
1703 ORRINGTON AVENUE
EVANSTON, ILLINOIS 60201

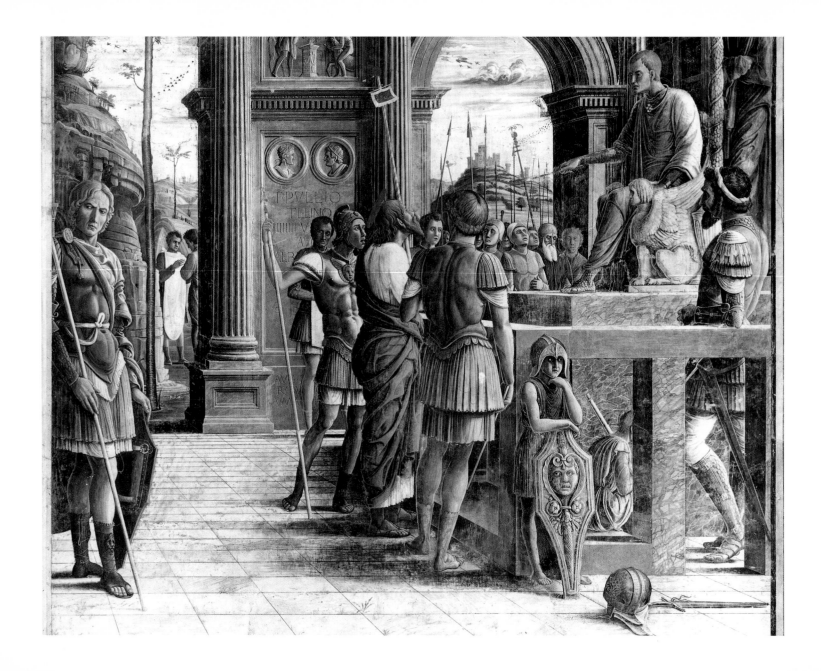

Andrea Mantegna

Padua and Mantua

Keith Christiansen

GEORGE BRAZILLER NEW YORK

Published in 1994 by George Braziller, Inc.

Texts copyright © George Braziller, Inc.

Color Pages 67-71, 79-81, 84-91 copyright © Scala/Art Resource, New York

Color Pages 75-77, 83, 93-96 copyright © Olivetti, Milan

Black and white illustrations copyright © Alinari / Art Resource, New York

All rights reserved.

For information, please address the publisher:

George Braziller, Inc.

60 Madison Avenue

New York, New York 10010

Library of Congress Cataloging-in-Publication Data:

Christiansen, Keith.

 Mantegna, Padua and Mantua / Keith Christiansen.

 p. cm. — (The Great Fresco Cycles of the Renaissance)

 Includes bibliographical references

 ISBN 0-8076-1327-4

1. Mantegna, Andrea, ca. 1431-1506—Criticism and interpretation.
2. Mural painting and decoration, Italian—Italy—Padua. 3. Mural painting and decoration, Renaissance—Italy—Padua. 4. Chiesa degli Eremitani (Padua, Italy). 5. Mural painting and decoration, Italian—Italy—Mantua.
6. Mural painting and decoration, Renaissance—Italy—Mantua.
7. Camera degli Sposi (Castello di San Giorgio, Mantua, Italy).
I. Mantegna, Andrea, ca. 1431-1506. II. Title. III. Series.

ND623.M3C47 1994 94-11626

759.5—dc20 CIP

Opposite title page: Mantegna, *St. James Before Herod Agrippa* (detail), Ovetari Chapel, Church of the Eremitani, Padua (destroyed). The Roman soldier at the far left is a self-portrait of Mantegna.

This book was set in the Monotype Centaur typeface

Designed by Lundquist Design, New York

Printed by Arti Grafiche Milanesi, Arese, Italy

Acknowledgments

In writing this book I am particularly conscious of my debt to Keith Shaw, who has generously shared his detailed knowledge of the Ovetari Chapel and lent me a draft of his thesis on it, and to Giovanni Agosti, who gave me privileged access to the *Camera Picta* on a portable scaffolding. Andrea Bayer has patiently listened to my patter and helped to shape my ideas. I also wish to thank students of two graduate seminars I conducted at Columbia University in 1991 and 1994 for the light they shed on court aesthetics in northern Italy. Adrienne Baxter kindly invited me to write for this series and she has seen the project into print in exemplary fashion.

Contents

In memory of my parents

Andrea Mantegna

PADUA AND MANTUA

A Mantegna Itinerary

IN THE LAST QUARTER OF THE fifteenth century the road most heavily traveled in northern Italy and the Veneto by artists and enthusiasts of Renaissance art was that running west from Padua to Verona and then south to Mantua. In the first city—seat of the second oldest university in Italy and a center of humanist culture—the goal would have been to see the frescoes by Andrea Mantegna (ca. 1431-1506) in the Ovetari Chapel of the Eremitani (church of Augustinian Hermits). This fresco cycle marks the advent of Renaissance painting in northern Italy, and its pervasive impact on Mantegna's colleagues can only be compared to that of Giotto's frescoes in the neighboring Scrovegni Chapel in the preceding century and Masaccio's work in the Brancacci Chapel in Florence, carried out some two decades earlier. The frescoes must have been studied with care by Dürer on one of his two trips to Italy, when Mantegna was perhaps the most widely admired artist in Europe. When Goethe visited the city in 1786, their impact was undiminished, and until an allied bomb was inadvertently dropped on the church during World War II, they continued to draw art lovers in great numbers.

The next stop would have been Verona, some fifty miles away, where Mantegna's *San Zeno Altarpiece* remains in the venerable Benedictine monastery of that name. This work is widely recognized as the most innovative altarpiece of the early Renaissance: the first in which the frame functions not as a surround but as the three-dimensional extension of the pictorial space and in which the Madonna and her heavenly court appear in a rigorously *all'antica* setting (fig. 1).

Verona is a mere twenty-five miles from Mantua, which, because of the fens and lake that all but surrounded it, had to be reached either by boat or across the Ponte di San Giorgio. If the traveler had procured the proper letters of introduction, he might conceivably have visited a private room in the Gonzaga castle frescoed by Mantegna between 1465 and 1474; upon its completion this room instantly established a new standard of secular decoration and, according to the duke of Milan, Galeazzo Maria Sforza, was considered

by all who saw it to be "the most beautiful room in the world."[1]

Today this same trip can be made by car in a single day, without the inconvenience of crossing the border of the Venetian state, which in the fifteenth century included both Padua and Verona, and entering the independent Gonzaga marquisate of Mantua. However, modern visitors on this pilgrimage begin their visit in Padua at a considerable disadvantage, since all but two of Mantegna's celebrated scenes in the Eremitani were destroyed (the surviving frescoes had been detached during the nineteenth century and at the time of the bombing were not in the chapel; even these two scenes are not completely legible). Fortunately, a photographic record of the individual scenes exists. Yet, as the impact of Mantegna's work—in Padua as later in Mantua—stems from the carefully calculated relationship of the architectural setting to the frescoed decoration, these photographs can give only a partial impression. The present book attempts to redress this insufficiency.

Mantegna and the Practice of Mural Painting in Northern Italy

THOUGH A FLORENTINE BY BIRTH, training, and disposition, Giotto created his most famous work, the Scrovegni Chapel frescoes, in Padua, and his activity there initiated a long and fruitful exchange between Florentine and northern Italian artists. He was followed by his

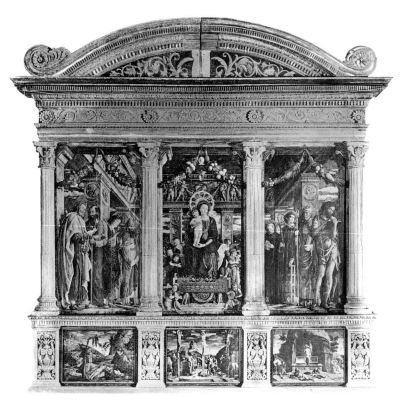

Fig. 1. Mantegna, *San Zeno Altarpiece*, Monastery of San Zeno, Verona

compatriot, the gifted painter Giusto di Menabuoi, who moved to Padua by 1370 (he was later considered a native Paduan), and, at the very end of the century, by Cennino Cennini, perhaps best known for his handbook on the craft of painting, *Il Libro dell'Arte*, our key source

for artists' techniques in the late middle ages. Cennino was employed in Padua by the ruling Carrara family. In the mid-1430s Filippo Lippi worked on a now lost cycle of frescoes in a chapel of the Palazzo del Podestà, and the following decade Paolo Uccello created a grisaille fresco cycle of giant figures in the Vitaliani Palace—also destroyed—which Mantegna purportedly admired. In 1442, in nearby Venice, Andrea del Castagno decorated the apse of the church of San Tarasio with figures of God the Father and saints that were, again, evidently admired by Mantegna, who as a youth must have visited the city frequently. As might be expected from this frequent infusion of Florentine artists, the basic techniques of fresco painting were pretty much the same north and south of the Appenines.

Indeed, like their Florentine contemporaries, northern Italian painters applied their diluted colors—the most suitable were earth pigments—directly to areas of freshly laid plaster (whence the word *affresco* or, more simply, *fresco*) so that, through the natural chemical process of carbonization, pigments bonded with the wall surface. Conventionally, gilding and finishing details were applied after the wall was dry (that is, *a secco*), as were certain pigments that required tempering with a glue or egg medium for application: azurite blue, for example, which was usually applied over a layer of red ochre since it otherwise tends to blacken or change color in contact with lime plasters;

vermilion; orpiment (a yellow sulphide of arsenic); verdigris (green obtained from copper resinate); and lake (a red resin). There was considerable variation within these parameters. We sometimes think of Giotto as the paradigmatic practitioner of true (or *buon*) fresco technique, planning out his work with a reddish or brownish chalk drawing (the *sinopia*) on a rough layer of plaster (usually referred to as the *arriccio*), and then proceeding to lay in relatively small areas of plaster that could be finished off in a single workday (or *giornata*). This seems, in fact, to have been his practice in Padua in the Scrovegni Chapel. But in at least one instance—Giotto's later murals in the Peruzzi Chapel in Santa Croce, Florence—the plaster was applied in wide horizontal bands (*pontate*) that corresponded to the various levels of the scaffolding, and the pigments, applied when the wall was already dry, were necessarily mixed with lime water or glue to make them adhere. This technique had its advantages, since it allowed work to proceed simultaneously along the breadth of the scaffolding (or *ponte*) rather than in a piecemeal fashion, but today Giotto's scenes are little more than tinted shapes (see the Glossary for further information on fresco technique).

Contemporaneously, Giotto's great Sienese contemporary, Simone Martini, pushed the craft of mural painting in another direction. His depiction of the Virgin and Child in majesty (the *Maestà*) amid a court of saints and angels on a wall of the Palazzo Pubblico,

9

Siena, has the textural richness and abundant use of tooled, gilt surfaces more commonly associated with panel painting (fig. 2). Simone was not adverse to embedding pieces of colored glass and cabochon jewels into the plaster or applying sheets of parchment to the wall surface to increase the effect of opulence or realism. Furthermore, he extended *a secco* work to enormous areas: the garments of the Virgin and the Christ Child and the cloth of honor draped over the gilt throne of the Palazzo Pubblico mural were all carried out *a secco* on a single patch of plaster: the heads and hands were later inserted in *buon fresco*.[2] Simone's haloes are in relief and stamped with a variety of motif punches, adding yet another level of richness. Behind his work was a firm mastery of *buon fresco*, and it would clearly be wrong to view his innovations as an aberration or even as a purely decorative adjunct to fresco practice. Rather, in his work he combined decorative splendor with a descriptive urge of unmatched subtlety.

In the fourteenth and early fifteenth century Simone's fame was scarcely inferior to Giotto's, and his murals forecast a distinctive line of development that was taken up in northern Italian painting. In his murals of the 1430s in the churches of San Fermo and Sant'Anastasia in Verona, Pisanello used gold and silver not merely as decorative adjuncts but as naturalistic embellishment. The militant archangels, perched high up in the fanciful tabernacles of a rose

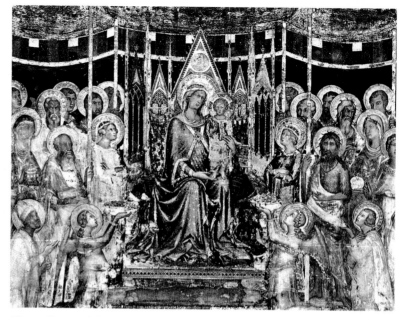

Fig. 2. Simone Martini, *Maestà* (detail), Palazzo Pubblico, Siena

arbor surrounding the San Fermo mural, and the knightly St. George in the Sant'Anastasia scene (fig. 3) sport silvered armor (the silver has now badly flaked and oxidized to a uniform black) that was variously burnished or tooled to simulate smooth steel plates and chain-linked mail. Hilts and horse harnesses were modeled in relief and silvered or gilded, while richly textured fabrics were suggested by glazing over silver tooled with patterns. Even the hat of the princess of Trebizond in the Sant'Anastasia mural had bands of

Fig. 3. Pisanello, *St. George and the Princess of Trebizond* (detail), Sant'Anastasia, Verona

tooled silver—as it would have had in actuality. Hardly restricted to finishing details, painting *a secco* was extended to the foliage of trees and shrubs, allowing a greater degree of descriptive verity and, at the same time, conferring a brilliance of color not obtainable in pure fresco technique. Today these areas must, in large part, be mentally reconstructed, since much of the paint has flaked away.[3]

Pisanello worked for the enlightened humanist courts of Ferrara and Mantua; for the latter he decorated a room with a mural cycle based on Arthurian legend, and it was his minutely descriptive style that formed the basis of courtly taste throughout northern Italy. To a degree, even Mantegna's own experiments with the full vocabulary of mural (rather than simply fresco) practice is indebted to the prior example of Pisanello.

In the vault of the Ovetari Chapel, where Mantegna worked with a slightly older artist, Niccolò Pizzolo, an oil lamp, modeled in plaster and gilt, appeared above the head of a figure of God the Father (fig. 4; the figure, now destroyed, was by Pizzolo), and the pommel and hilt of Mantegna's accompanying figure of St. Paul were likewise built up in relief. These details might be thought of as curious survivals of Gothic practice, for on the whole Mantegna subscribed to a preference first formulated by the humanist-theorist-architect Leon Battista Alberti to simulate metallic surfaces with paint rather than with precious metals. And yet, in the later *Camera Picta* at Mantua, we find the ribbon lacing of the fruit swags that surround Mantegna's famous trompe l'oeil *oculus* edged in gold, while the vault is in part in gold leaf incised to simulate mosaic. The brocade hangings that fill two of the four walls were carried out in gold leaf applied over a fresco preparation with overlaid patterns painted *a secco*, as were some of the richly brocaded costumes, including that of the Marchioness Barbara of Brandenberg. On the principal wall of the room, on which the

Fig. 4. Niccolò Pizzolo, oil lamp above God the Father, Ovetari Chapel, Church of the Eremitani, Padua (destroyed)

Marquis Ludovico Gonazaga is shown seated with his wife, Mantegna painted figures *a secco* on large patches of plaster (*pontate*), possibly as a technical experiment to counterbalance the damp to which this external wall was prone in the city's dank climate (if this was so, the experiment was unsuccessful, and the mural has suffered gravely). In various areas oil seems actually to have been employed as a medium. By contrast, Mantegna carried out the adjacent internal wall, which shows Ludovico greeting his son Cardinal Francesco Gonzaga, predominantly in *buon fresco*, but on *giornate* of unusually small size so that he could elaborate the detailed physiognomy in a way that Pisanello would have envied. Even so, Mantegna had to resort to *a secco* painting to obtain the desired detail and brilliant color of the foliage and swags of fruit. Although most of the scenes of the Ovetari Chapel have been destroyed, photographs make it clear that Mantegna could have obtained the detailed realism of the figures—passages like the head of the converted pagan Hermogenes with the drops of baptismal water bouncing off its bald surface—only through the same strong reliance on *a secco* painting.

By the 1450s extensive use of *a secco* painting was fairly common throughout Italy. For example, the great barren tree that fills the lunette of Piero della Francesca's scene of the death of Adam in his celebrated cycle at Arezzo originally had leaves painted *a secco*, and the

reflective surfaces of the armor worn by Constantine and of the Tiber River were, again, possible only by bending the practice of *buon fresco*. Filippo Lippi's work in Prato Cathedral had numerous *a secco* passages, the loss of which has significantly diminished the scenes' impact. Even the use of oil was not as uncommon as is sometimes thought: Domenico Veneziano's lost fresco cycle in the church of Sant'Egidio in Florence was said to have been at least partly carried out in oil, and the technique was widespread enough that the contract for the Ovetari Chapel specified that work was to be "ad friscum et non ad oleum" (in fresco and not in oil). In all of these cases artists extended or modified the technique of fresco painting to meet the increasingly sophisticated humanist taste and the emerging criteria of art criticism, to which Mantegna's art both contributed and responded to a degree that has not, perhaps, been sufficiently appreciated.

The Ovetari Chapel, Padua

AS OFTEN AS NOT, Renaissance frescoes decorated Gothic interiors whose features offered a far from sympathetic ambiance. This was the case with the Ovetari Chapel, and it presented two basic options to the artists who filled its vaults and walls: ignore the existing architecture and concentrate on the broad expanses of wall, or find some way of reconciling the style of the frescoes with the architecture. In general, Paduan artists preferred the latter course, taking as their model Giotto's frescoes in the Scrovegni Chapel. As a complement to his weighty figures, Giotto had conceived a marvelous, simulated architectural framework that employed a wainscoting with feigned sculpture in low relief and moldings inlaid with mosaics. The ribbed vaults and compartmentalized space of the Ovetari Chapel did not lend itself easily to this sort of treatment, and the audacious decision of Mantegna and his partner Niccolò Pizzolo to reconfigure the real architecture by pushing to new heights the wand-like potential of the brush to transform appearances was nothing short of revolutionary. In so doing, they transformed the very possibilities of mural painting.

Because of the novelty and wide impact of the decorative scheme devised by Mantegna and Pizzolo, it is worth underscoring the fact that the appearance of the chapel as completed by Mantegna owed almost nothing to the man who provided the funds for it, and a good deal to a series of mishaps that foiled the initial scheme but worked in Mantegna's favor.

From the latter half of the fourteenth century the chapel was under the patronage of the prominent Ovetari family; the last male heir of the family's principal line, Antonio Ovetari, provided for its decoration in a will drawn up in 1443. Antonio's wealth came from real estate, and the only other evidence of an interest in the arts was

his funding of a reliquary to contain the most venerated relic in the city, the tongue of St. Anthony, housed in the basilica of the Santo (or St. Anthony). Ovetari's chapel bore a double dedication to the apostle St. James the Greater and to St. Christopher (who shares the same feast day). In the various redactions of the will Antonio specified simply that the chapel be decorated in an honorable and appropriate fashion with a fresco cycle of the lives of these two saints and that there be a grill at the entrance. Not surprisingly, the iconographic program—a matter of special interest to the clergy—was not mentioned, and the eventual decision to treat the lives of the two saints on opposite walls and to attempt to make some very loose thematic correlations among the events illustrated was the only practical one possible. As executed, six events from the life of each saint were selected, and these can be said to share the following themes: the saint's vocation; his confrontation with the devil; his ministry; his arrest; and his martyrdom (treated in two episodes).

Details of the program and decoration were dealt with by Antonio Ovetari's executors and his widow, Imperatrice Forzate.[4] The Forzate were a branch of one of the grandest of all Paduan families, the Capodilista, who had long-standing attachments to the prestigious law faculty at the university, and among his executors Antonio included Giovanni Francesco Capodilista, a knighted doctor of law, and Giovanni's son Francesco. Not much is known about Francesco, but from the little evidence that survives, he appears to have been a person of some cultural ambition who wrote Petrarchan verse and served on the supervisory board of the Eremitani. He had, moreover, visited Florence as attorney to his brother-in-law Antonio Borromeo in 1441 (Mantegna would include Borromeo's portrait in one of the scenes in the Ovetari Chapel), and there he would have had firsthand contact with the nascent Renaissance style. Fittingly, Francesco's name heads the contract for the decoration of the chapel, drawn up on May 16, 1448, and presumably this young but already eminent figure was behind the remarkable group of artists assembled to carry out the decorations.[5]

The idea of involving a group of artists rather than an individual to work on a single decorative project may strike us as strange, but it was far from uncommon. The contributions of Masolino and Masaccio to the decoration of the Brancacci Chapel in Florence are usually studied as an extreme case in artistic collaboration, but even in Florence other cycles were carried out in this fashion. In Venice and the Veneto collaborations in which independent masters were contracted to paint separate parts of a single project occurred with greater frequency, especially when the project was large or when the patron wanted to speed up production.

Antonio Ovetari's executors envisaged completion of the frescoed decoration within two and a half years, which proved hopelessly optimistic (the task took upward of nine), and to accomplish this they turned to two teams of artists. The first was the well-established Venetian workshop of Giovanni d'Alemagna and Antonio Vivarini. The artists were related by marriage, ran an efficiently organized joint enterprise, and had behind them a series of prestigious commissions, both in Venice, where they had provided altarpieces for the church frescoed by Andrea del Castagno, and in Padua. Although today their work is frequently characterized as late Gothic, they belonged to the avant-garde of Venetian painting and had introduced classical epigraphy as well as perspectival settings in their multi-paneled altarpieces. Their task was to decorate the Ovetari Chapel's vault with images of the four evangelists (fig. 5), the inner face of the entrance wall with a scene of the Passion (in fact, never executed), and the one lateral wall that could be seen from the nave of the church with the story of St. Christopher. However, Giovanni d'Alemagna died in 1450, before completing the vault, and his brother-in-law thereupon withdrew from the commission. Perhaps Antonio Vivarini felt that altarpieces rather than murals were his forte and that he had sufficient work elsewhere to occupy him, or perhaps he was simply not prepared to meet the

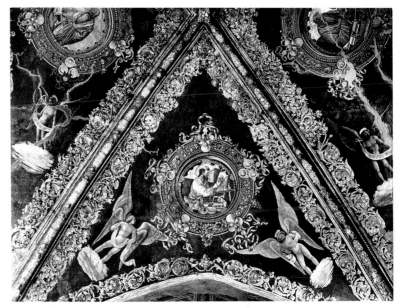

Fig. 5. Giovanni d'Alemagna and Antonio Vivarini, *The Evangelist St. Luke*, Ovetari Chapel, Church of the Eremitani, Padua (destroyed)

imposed deadlines and an increasingly anxious Imperatrice Forzate, who upon Vivarini's withdrawl lost no time in hiring at least three artists to speed production along. Two of these can be identified with certainty, both from the account records and from the two scenes of the life of St. Christopher that, until their destruction, bore their signatures. One was the local-based Ansuino da Forlì, who had purportedly worked in Padua with Filippo Lippi in the chapel of the Palazzo del Podestà. The other was Bono da Ferrara,

a pupil of Pisanello, who undertook his work for Imperatrice clandestinely and was forced by the painter's guild in Padua to leave the city after completing the one frescoed scene of St. Christopher carrying the Christ Child. The third may well have been the itinerant Marchigian painter Girolamo di Giovanni da Camerino, who joined the painter's guild in Padua in 1450 and to whom the first scene in the lunette has reasonably been attributed (the second may or may not be by Ansuino). These artists worked independent of each other, and with their hire (probably at a substantially lower rate of payment than that originally negotiated with Giovanni d'Alemagna and Antonio Vivarini) the St. Christopher cycle became a collage of artistic interests, culminating in the two climatic episodes painted by Mantegna, the only scenes from that cycle that survive today.

The second team of artists was comprised of the two rising stars of Paduan painting, Niccolò Pizzolo and Andrea Mantegna. They were hired to create an altarpiece sculpted in terra cotta as well as to decorate the apse of the chapel with, in the vault, figures of God the Father and Sts. James, Peter, Paul, and Christopher and, below them, the four church fathers; the back wall with the *Assumption of the Virgin*; and the wall opposite that of St. Christopher with the story of St. James. Niccolò Pizzolo was already a master of some repute: Like Ansuino da Forlì, he had contributed to a fresco cycle in the chapel of

the Palazzo del Podestà (whether he was old enough actually to have worked with Lippi cannot be confirmed), and he was concurrently associated with Donatello on the Florentine sculptor's elaborate, freestanding altarpiece incorporating bronze figures and bronze and marble reliefs for the high altar of the pilgrimage church of the Santo—unquestionably the most prestigious ecclesiastical undertaking in Padua and one of three outstanding commissions given to Donatello during his ten-year sojourn there from 1443 to 1453. It was certainly Pizzolo's association with Donatello that earned him the commission of the altarpiece for the Ovetari Chapel (fig. 6).[6]

Mantegna may have been no more than eighteen when he signed the contract for the Ovetari Chapel frescoes.[7] Previously he had been employed by the prominent Paduan artist Francesco Squarcione, a rather unsavory if enterprising character who had the practice of adopting his prize pupils in order to avoid the obligation of reimbursing them for their work or of paying their entrance fees to the painter's guild. This arrangement undoubtedly rankled Mantegna, who knew full well that Squarcione's limited abilities as a painter made success dependent on the precocious talent of his pupil. Things came to a head when the two were in Venice in 1447; at Mantegna's insistence the association was formally dissolved on January 26, 1448. Just four months later Mantegna joined forces with Pizzolo.

It was an ill-fated union. Pizzolo had a police record as a rabble-rouser, and both he and Mantegna were headstrong. As partners they were expected to work as a team, devising the designs for their frescoes in a way that would ensure some sort of stylistic coherence and, equally important, expedite the task. But within a year their competing ambitions brought work to a standstill—there is some evidence that each tried to impede the work of the other by blocking light or locking access to the scaffolding—and their contract had to be renegotiated, with their individual responsibilities spelled out. Mantegna was assigned all but the final scene of the life of St. James, which was reserved for Pizzolo (whose senior status emerges clearly from the various documents). However, when Pizzolo was mysteriously murdered in 1453, this scene also fell to Mantegna, together with the *Assumption of the Virgin* in the apse. As a result of these complicated and completely unforeseen circumstances, the Ovetari Chapel became, quite literally, the training ground for a whole generation of young artists as well as the first and most powerful affirmation of Mantegna's art. Its loss has deprived us of the key document in the history of northern Italian Renaissance painting.

There is a variety of ways in which the prewar photographic record of the Ovetari Chapel can be approached. By focusing on the contribution of each artist, we can attempt to define the salient

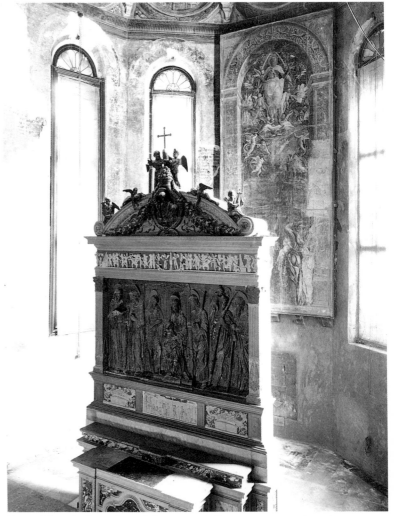

Fig. 6. Niccolò Pizzolo and Giovanni da Pisa, terra cotta altarpiece, Ovetari Chapel. (Mantegna's *Assumption of the Virgin* is in the background.)

traits of some of the key personalities of northern Italian painting. Or, by isolating Mantegna's work and following its progress over the nine-year period, we can map out the steps by which he liberated himself from local precedent—in this case the initially dominating personality of Pizzolo—to create a language that was all his own. However, neither approach does justice to the chapel as a whole and to those features that gave it coherence despite the various contributing hands. To do this, it is necessary to attempt mentally to re-create the experience of a fifteenth-century visitor to the chapel and the frescoes' unprecedented dramatic impact. Fortunately, enough photographs—although not always of fine quality and frequently omitting portions of the chapel crucial to its overall effect—survive to make this enterprise just feasible.

The chapel in which the frescoes were located is in the right transept of the church, and the first view of it is from the main aisle as the visitor approaches the crossing (fig. 7). From this vantage point only one wall—that with the story of St. Christopher, depicted in six episodes—is visible, and the entrance arch to the chapel allows only the bottommost tier, with two scenes painted by Mantegna, to be seen in its entirety. At the left is St. Christopher being shot with arrows, and to the right is his subsequent decapitation (see also pp. 67-69). Chronologically, the two scenes were among the last (possibly the last)

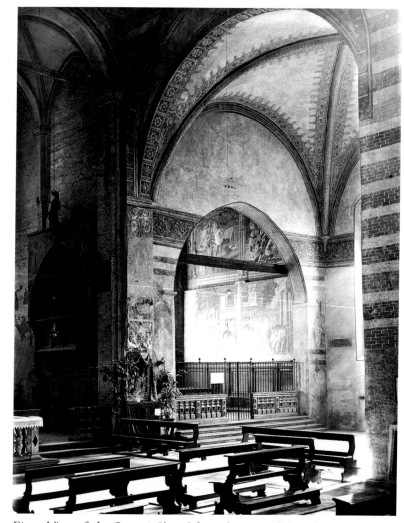

Fig. 7. View of the Ovetari Chapel from the nave of the Church of the Eremitani (pre-World War II photograph)

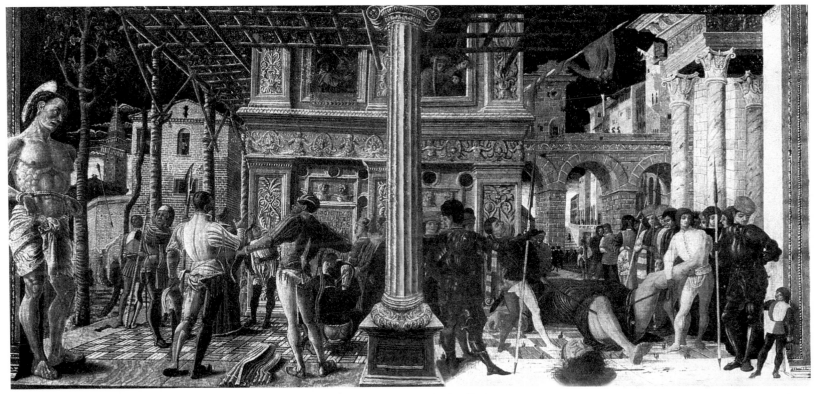

Fig. 8. Copy after the *Martyrdom of St. Christopher* by Mantegna, Musée Jacquemart-André, Paris

painted in the chapel, and on these grounds they ought to be studied last. However, insofar as Mantegna meant them to introduce the viewer into the world of the chapel and as they were fortunate enough to have survived the bombing, pride of place belongs to them.

The view from the nave of the church was clearly important to Mantegna, who united the two scenes with a classical molding that filled the width of the wall. Unfortunately, damage to the fresco makes it necessary to refer to an early copy, now in the Musée Jacquemart-André in Paris, to appreciate its intended effect (fig. 8). The molding is divided by an Ionic column that functions as a mullion in a window.

To the left the giant St. Christopher (now obliterated) was shown bound to the molding itself—projecting illusionistically into the viewer's space—while his executioners are grouped within the deep space of a city square, struggling with the ricocheting arrows that refuse to hit their intended victim. To the right of the column lies the prostrate body of the saint, shown feet first in steep foreshortening—a precursor of Mantegna's celebrated painting on canvas of the dead Christ in the Pinacoteca di Brera in Milan—while his detached head (no longer visible) was depicted disconcertingly close to the fictive ledge of the enframing molding, as though it might roll into the chapel itself. To the extreme right, balancing the bound figure on the opposite side and posed so that they break through the picture plane and engage the viewer's attention from the nave, are a soldier and his page. The panoramic city view, punctuated by an arched bridge from which bystanders observe the action, is of incomparable vivacity, and must have seemed even more so before large areas of the azurite blue sky (azurite was specified in the contract) had fallen away, revealing the reddish underpainting. Not the least notable detail of this scene is the tunneling grape arbor, whose unimpeded *di sotto in sù* recession further heightens the dramatic impact. Only in Donatello's narrative bronze reliefs for the Santo altarpiece showing miracles of St. Anthony can a precedent for the charged language of Mantegna's scene be found

(fig. 9). There can be no doubt that Mantegna studied Donatello's reliefs closely, though he was less interested in the compact figure groups close to the picture plane than in the sculptor's habit of overlapping framing elements with gesticulating figures and his use of ceiling beams depicted in steep foreshortening both to define depth and heighten the dramatic impact.

The illusionistic *all'antica* frame and panoramic background of the *Martyrdom of St. Christopher* were intended to register from a distance and draw the viewer into the chapel, setting the stage, so to speak, for the most novel aspects of its decoration. Today, faced with the banal Gothic architecture of the chapel and its dismal bare walls, it is almost impossible to participate, even vicariously, in the excitement the fresco cycle once generated, but the very nondescript character of the chapel ought to underscore the achievement of the artists who worked in it, and particularly of Pizzolo and Mantegna, whose personalities dominated the whole enterprise after the death of d'Alemagna and the withdrawal of Vivarini (their four evangelists on the ceiling, shown in timidly illusionistic *tondi*, would have been impressive on their own, but in the completed chapel they must have registered as footnotes). In the vault of the apse, powerfully sculptural figures of God the Father, seated on a bank of clouds against a rainbow mandorla borne aloft by cherubim and

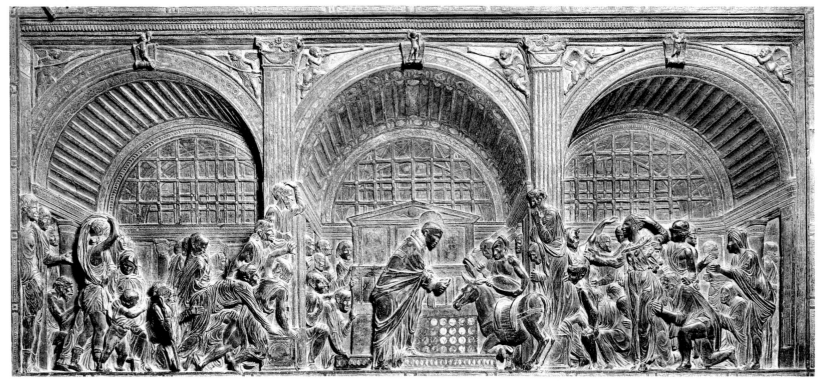

Fig. 9. Donatello, *The Miracle of the Mule*, Basilica of St. Anthony, Padua

seraphim, and Sts. James, Peter, Paul, and Christopher were depicted as though viewed in the sky through a cage of marble moldings carved with vegetable motifs from which heavy garlands of fruit were suspended (God the Father was by Pizzolo, Sts. Peter, Paul, and Christopher by Mantegna). The effect was enhanced by fluttering ribbons and details such as the illuminated lamp hanging above God the Father, modeled in plaster and foreshortened as though seen from below, and the heavy clusters of grapes that hung suspended over the standing saints. By these devices the actual ribs of the vaulting were made to participate in the pictorial tranformation of the chapel's architecture.

Below these figures, flanking a large circular window, Pizzolo

created four fictive *oculi* surrounded by deep moldings viewed in steep foreshortening. The richly decorated surfaces and emphatic illusionism of these mouldings strongly recalled Donatello, but instead of enhancing the tridimensionality of a sculptural relief, they framed views into the studies of the four church fathers, Sts. Ambrose, Gregory, Augustine, and Jerome, shown busy at their desks. Open cupboard doors, projecting lecterns, and patterned ceilings—forerunners of Mantegna's grape arbor in the *Martyrdom of St. Christopher*—activated the space and suggested a continuum with the actual space of the viewer. This effect was further enhanced by painted architectural moldings around the four arched windows beneath the frescoes of the church fathers. These were painted after Pizzolo's death. A fifth fictive window, with the same classical moldings, was conceived by Mantegna as the frame for the *Assumption of the Virgin*, and here, as in the St. Christopher scene, he showed a special concern for the way the fresco would be perceived by the viewer. Only the top half, showing the Virgin soaring heavenward amid a frolicking band of cherubs, is visible from the main body of the chapel; the lower half is blocked by Pizzolo's terra cotta altarpiece, the top of which was decorated with putti whose attitudes Mantegna clearly took into account (see fig. 6). To see the lower half, showing the apostles gazing up at the Virgin's ascent, it is

necessary to walk behind the altar (once positioned closer to the back wall, where it received proper light from the windows). From this vantage point the angle of vision is steep, and to accommodate it Mantegna elongated the torsos and legs of the apostles, who, unlike Pizzolo's God the Father and church fathers, are not contained by the fictive architecture but spill out of the arched space into the chapel itself. The *Assumption* was among the last things Mantegna painted in the chapel, and in it illusionism is used not as artistic display but as a dramatic device. In this it announces the mature work of Mantegna and his fresco cycle in the *Camera Picta* at Mantua.

The lateral wall of the chapel, with the story of St. James, was painted by Mantegna before both the *Martyrdom of St. Christopher* and the *Assumption of the Virgin*. Indeed, its upper register, with its scenes of the *Calling of St. James and St. James and the Demons*, contained Mantegna's earliest surviving efforts at narrative painting. As was not the case with the *Martyrdom of St. Christopher* and the *Assumption*, the framework of these scenes was predetermined by the marble moldings created by Pizzolo for the vault and made conscious reference to the fourteenth-century frescoes by the Paduan painter Guariento in the apse of the church. The scheme is sculptural rather than architectural in effect and was adapted in modified form by the artists of the St. Christopher cycle (nothing demonstrates more clearly the degree to

which Pizzolo's and Mantegna's were the dominant imaginations in the project as well as the attention their work received from the other artists). As in the vault, swags of fruit enlivened the scheme with bright colors (the marble moldings were, of course, monochromatic) and introduced a further element of spatial illusionism, as the swags appeared to hang on the viewer's side of the enframing moldings. It was an ambivalent system whose effectiveness was dependent on the treatment of the individual scenes. Only in the middle tier, in which Mantegna unified the settings of two separate episodes behind the molding—as he was to do later in the *Martyrdom of St. Christopher*—did the effect become decisively illusionistic. In his influential treatise on painting of 1435, Alberti had defined painting as "an open window through which the subject to be painted is seen," and this was Mantegna's intended effect. He paid great attention to describing the depth of the molding and to the play of light over it and took no less care to avoid any confusion between the molding and the squared pavement of the scene, the front edge of which stopped conspicuously short of the picture plane (this sort of minutely analytic mind is absent from the frescoes by Bono da Ferrara and Ansuino da Forlì, who in other respects attempted to emulate Mantegna's scheme).

In the bottommost tier, containing the scenes of St. James being led to execution and his beheading, Mantegna abandoned the

Fig. 10. View of the story of St. James, Ovetari Chapel (destroyed)

idea of the framed picture for a more dynamic conception in which the action was allowed to spill out of the frame, which was dynamically redefined as the border between the space of the pictorial action and that of the chapel. The scenes occupied a position immediately above the viewer's head upon entering the chapel, and normally one saw them from close range (fig. 10). Taking this circumstance as his point of departure, Mantegna made the vanishing point of these two frescoes coincide more or less with the actual height of the viewer, so that the ground plane slipped out of view

as it receded into the distance. In one scene the toe and heel of two of the bystanders projected into the viewer's space, conferring a quality of immediacy to the dramatically charged moment, which was depicted as taking place amid great commotion, while in the other scene a railing was illusionistically attached to the outside of the molding. A spectator leaning over the molding entered, in effect, the viewer's space, and the head of St. James, on a portable guillotine, threatened to drop into the chapel. In both cases the effect was one of dramatic urgency.

Difficult as it is mentally to re-insert the two remaining, much damaged frescoes of the Ovetari Chapel into the preexistent scheme, it is perhaps even harder to appreciate just how revolutionary was the illusionism governing their conception. Nonetheless, if we compare Mantegna's frescoes to those of Masaccio in the Brancacci Chapel or, even more strikingly, to those of Piero della Francesca at Arezzo, which are exactly contemporary, we cannot help but be struck at the novelty of his achievement. In the work of Masaccio and Piero the stories are self-contained: no figure or object projects beyond the picture plane and the viewer's participation in the event depicted is not actively sollicited. Masaccio attempted, with somewhat unsatisfactory results, to foreshorten the architecture of his framework to the vanishing point of the individual scenes (in one case, an architectural pier seems to sit in a river bed), but Piero forewent even this element of illusionism. His fresco cycle invites the viewer's contemplation rather than engagement—which is one of the reasons his work appeals so strongly to a generation brought up on the paintings of Seurat and Cézanne. Mantegna's use of illusionistic devices to engage the viewer and his emphasis on the physical proximity of his dramatis personae are in many respects closer to the art of Donatello; this similarity of purpose underscores the importance of Mantegna's short-lived association with Pizzolo, who had worked with the great Florentine sculptor and, like Donatello, conceived of his craft in profoundly physical terms.

We would do a serious disservice to Mantegna and his contemporaries if we assumed that he expected viewers to be taken in by his tricks of illusionism—either in the Ovetari Chapel or in the *Camera Picta*. The projecting feet and railing were conceitful cues meant to engage the viewer dramatically and intellectually. This was fully understood by his contemporaries, who recognized in Mantegna an "exalted and bright genius."[8] Today it is all too easy to underestimate this aspect of Renaissance art, which on the whole was addressed to a highly intelligent and, above all, literate audience; one brought up with a keen appreciation for verbal and visual display—to the degree of frequently appreciating form over content.

A primary aim of a humanist education was the cultivated appreciation of masterfully crafted eloquence: the finely turned phrase, the well-found analogy, the polished delivery that kept audiences rapt during an otherwise vacuous speech lasting two or more hours. It was, above all, to this audience that Mantegna's frescoes in the Ovetari Chapel were addressed. The proof of this is in the quantity of archeological detail included in the various scenes—details that were bound to strike a responsive chord in the close-knit group of Paduan antiquarians: collectors of classical epigraphs and drawings of ancient monuments (not least among these had been the archbishop Pietro Donato, friend of that insatiable recorder of the monuments of the eastern Mediterranean, Ciriaco d'Ancona; he died in 1448, the year the frescoes were commissioned). Some of these men were included as onlookers in the *Martyrdom of St. Christopher*, although they had had nothing to do with the commission.

Thus a literary frame of mind informs these frescoes, and we would do well to look at them with the eyes of a humanist brought up on the Roman authors Cicero and Quintillian, who provided the models for Renaissance writers and orators. It has long been established that Alberti's treatise on painting was largely conditioned by his reading of Cicero and Quintillian, but Alberti was hardly alone in this. Every humanist writer who took up the pen in praise of painting fell back on these two primary sources, for it was an axiom of classical literary theory that painting and poetry were related both in their means and their goals: "for a painting is, indeed, nothing else but a wordless poem," declared the northern Italian humanist Bartolomeo Fazio, paraphrasing a celebrated proverb of Simonides recorded by Plutarch.[9]

Many of the recommendations Cicero and Quintillian gave to the prospective orator were germane to the problems of narrative painting Mantegna encountered in the Ovetari commission, and nothing is more likely than that under the guidance of a humanist acquaintance the artist progressed from Alberti's treatise on painting to the ancient texts that had inspired it. Consider the following: according to Cicero and Quintillian, the three aims of the orator are to instruct, to move, and to charm his audience. To this end he must master the five parts of oratory: invention, arrangement, expression, memory, and delivery, or action. Memory had to do with having the right facts and figures at one's fingertips, and when we consider Mantegna's well-stocked catalog of archeological details, which enabled him to conceive of the history of St. James in appropriately Roman terms, there seems not to have been much difficulty in moving from these to the challenges of painting.[10] As to the issue of gesture, on which painting is so largely dependent for its communication of action and emotions, Cicero advised: "But all these

emotions must be accompanied by gesture—not this stagy gesture reproducing the words but one conveying the general situation and idea not by mimicry but by hints. . . . For by action the body talks, so it is all the more necessary to make it agree with the thought."[11] Alberti concurred, censuring exaggerated bodily movements in favor of pleasing and graceful ones "that are suitable to the subject of the action."[12] Even the use of rhetorical devices or literary figures of speech to enliven, embellish, or ornament a discourse was relevant to the artist. Quintillian actually compared such embellishments to the way sculptors and painters vary the dress, expression, and attitude of their figures, noting that the "body when held bolt upright has but little grace. . . . But that curve, I might almost call it motion . . . gives an impression of action and animation."[13] Quintillian even defended the rhetorician's ability to persuade someone to adopt a false opinion by making an analogy to the painter who "by his artistic skill makes us believe that certain objects project from the picture, while others are withdrawn into the background, [yet] he knows perfectly well they are really all on the same plane."[14]

Complete texts of Quintillian and Cicero were discovered, with great fanfare, in 1416 and 1417, and among the first to receive copies was the leading Paduan humanist Gasparino Barzizza, with whom Alberti was studying at the time. While Mantegna surely did not

Fig. 11. Detail of putti from *St. James Preaching*, Ovetari Chapel (destroyed)

plod through the two lengthy Latin texts, perhaps he took cues from his learned friends—among whom he would soon include Alberti himself. One of the many things in the Ovetari Chapel this

well-versed audience would have admired was the witticism of Mantegna's frolicking putti, who managed both to enliven and to comment on the various hagiographic episodes (discussed later in this book). In the scene of St. James disputing with demons, for example, a putto was shown desperately pulling himself to safety above the group of devils (fig. 11), and to the side of the scene of St. James baptizing the magician Hermogenes, a putto, hanging precariously from a garland, peed in fear (fig. 12). The stream of urine made a pun on the baptismal water poured over Hermogenes's head and, at the same time, cleverly suggested to an attuned viewer that a baptism of an unanticipated sort threatened the inattentive visitor. Strange though these witty interpolations may strike the modern viewer, appearing as they did in a church of monks, they could not have had a finer classical pedigree. In his treatise on oratory, Cicero reminds his reader that not only should the orator have an understanding of all human emotions so that he can kindle the feelings of his audience, but "to this there should be added a certain humour, flashes of wit, the culture befitting a gentleman . . . the whole being combined with a delicate charm and urbanity."[15]

In that same scene of *St. James Baptizing Hermogenes* Mantegna introduced a visual *figura*, to use Quintillian's rhetorical term, by juxtaposing the graceful, curving pose of a back-viewed spectator next

Fig. 12. Detail showing a peeing putto from *St. James Baptizing Hermogenes*, Ovetari Chapel (destroyed)

to another who stands bolt upright. But nowhere do we come so close to Mantegna's approach to painting as in the scene of *St. James Before Herod Agrippa*, where the artist himself made a cameo appearance as a stern-faced soldier staring threateningly from behind the enframing molding (see p. 51). His role was that of a choric figure who, to quote from Alberti's treatise, "tells the spectators what is going on, and either beckons them with his hand to look or with ferocious expression and forbidding glance challenges them not to come near."[16] A young page wearing his master's oversized helmet was shown as though pretending not to notice the autobiographical intrusion, averting his shadowed eyes. But the decorative head on the shield he held evidently could not resist the temptation, and in a fashion worthy of Cocteau, it cast an apparently incredulous glance at the intrusion of the painting's author, who only a moment ago was perhaps behind the fictive molding where, fittingly enough, the receding lines of the marble pavement converged in the vanishing point. (In the *Camera Picta* Mantegna makes a no less surprising appearance disguised as part of the carved decoration of a fictive pilaster dividing one of the scenes; fig. 13).

What Mantegna provided in these frescoes was a brilliant performance for an audience prepared to appreciate every inflection. It was delivered in a rich, humanist language that combined levity with

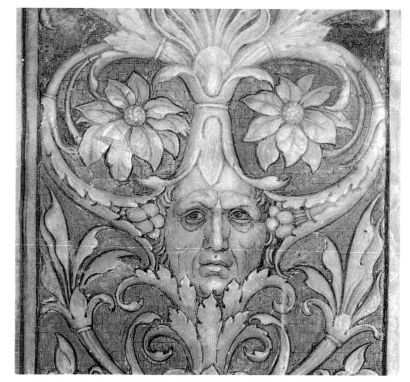

Fig. 13. Self-portrait of Mantegna as part of the decoration of a pilaster in the *Camera Picta*, Mantua (see also p. 87)

seriousness and urgency with learning. It made the Ovetari Chapel the pivotal work of the early Renaissance and led to Mantegna's invitation to become the court painter of one of the greatest humanist rulers, Ludovico Gonzaga at Mantua.

The Camera Picta, *Mantua*

IN 1460 MANTEGNA MOVED with his wife Nicolosia (daughter of Jacopo Bellini) and his household from Padua to Mantua. By that time he had already been in communication with Ludovico Gonzaga for nearly four years and had been commissioned to design and decorate a chapel (long since destroyed) in the castle of San Giorgio built by Ludovico's grandfather at the northeastern extremity of the city. Ludovico intended to refurbish the castle as a permanent residence in preparation for the church council held in Mantua in 1459. When Mantegna arrived, he found he had been preceded by Alberti, who had accompanied Pope Pius II to the council and had been retained by Ludovico to undertake an architectural commission. Alberti subsequently visited the city a number of times as he became Ludovico's favorite architect. It was Alberti's habit to provide designs and advice while a professional builder supervised construction. At Mantua this role was filled by the Florentine-trained Luca Fancelli, who had also arranged for Mantegna's transfer to the city. While we know little about Alberti's acquaintance or friendship with Mantegna, the two had much in common. Of course, Alberti belonged to a different social world. He came from an illustrious Florentine family, and although illegitimate and, until 1428, a political exile, he had received a humanist education with Gasparino Barzizza in Padua, learning Greek and Latin. He soon established himself as one of the outstanding Latin stylists and mathematicians of the day. His interest in the arts began as a side line, but by 1450 he had written a treatise on painting, another on sculpture, and the most ambitious architectural treatise since antiquity. Unlike Mantegna, whose reputation was based on what was still considered a menial craft, Alberti enjoyed equal footing with the princes and humanist popes who sought his company—foremost among whom were the marquis of Ferrara Lionello d'Este, the tyrant of Rimini Sigismondo Malatesta, Federigo da Montefeltro, Duke of Urbino, Ludovico Gonzaga, and Popes Nicholas V and Pius II. Perhaps partly because of his illegitimacy and the deprivations he had suffered as a youth (after the deaths of his father and uncle, his relations moved quickly to disinherit him), Alberti prized talent and genius over birth, and in Mantegna he must have recognized the ideal artist he had envisaged in the treatise he had written a quarter of a century earlier.

The Latin edition of Alberti's treatise on painting had been dedicated to Ludovico's father, Gianfrancesco Gonzaga, who had hired the outstanding educator Vittorino da Feltre to open Casa Giocosa, which would become the most celebrated school of the day for the instruction of his children along humanist lines (Vittorino had lectured in Padua when Alberti was there as a student of Barzizza). There,

Ludovico, together with his fellow pupils Federigo da Montefeltro (the patron of Piero della Francesca and deep admirer of Mantegna's work) and Gregorio Correr (the future papal protonotary at Verona and commissioner of Mantegna's *San Zeno Altarpiece*), had learned their Cicero and Quintillian as well as their Euclid and Plutarch and had, in all likelihood, studied Alberti's treatise. Also, Ludovico was an amateur architect. He owned a copy of the treatise on architecture written by the ancient architect Vitruvius, which he loaned to Alberti, and he must also have been an avid reader of Alberti's even more comprehensive treatise on the subject.

It was, perhaps, during one of Alberti's visits to Mantua that the project of decorating the marquis's private audience chamber/bedroom with a fresco cycle depicting the members of his family and court was first broached. There was nothing exceptional in the idea: during these same years Galeazzo Maria Sforza conceived successive projects for the decoration of rooms in his residences in Pavia and Milan with scenes of himself hunting, portraits of prominent court figures, and a cycle of frescoes containing family and dynastic portraits.[17] Ludovico intended to portray his family, courtiers, and foreign relations such as the Emperor Frederick III, who was technically his suzerain, and King Christian I of Denmark, who had married his wife's sister. There were also to be depictions of his pet dogs, the favorite of which was named Rubino, and one of his prize horses—a far from frivolous inclusion when we recall that hunting was the most highly regarded court pastime and that Ludovico's livelihood depended on his abilities as a war captain. (Later, in the sixteenth century, Mantegna's successor as court artist, Giulio Romano, would decorate a room in the Gonzaga's suburban villa, the Palazzo Tè, with life-size depictions of Gonzaga horses.) Mantegna's task was to flesh out the bare bones of this conventional task in a way that would confer both vivacity and dignity on the Gonzaga court. The means he chose was—not surprisingly—an illusionistic architectural setting conceived along Albertian lines with an emphasis on portraiture as narrative.

On April 26, 1465, lime for the walls was ordered; the date June 16, 1465, painted as a simulated graffito on the embrasure of one of the windows, both commemorates the beginning of work and refers to the birth of Ludovico.[18] A gold tablet supported by winged putti commemorates the conclusion of the enterprise and is inscribed in Latin, "For the illustrious Ludovico, second Marquis of Mantua, best of princes and most unvanquished in faith, and for his illustrious wife, Barbara, incomparable glory of womankind, his Andrea Mantegna of Padua completed this slight work in the year 1474." Following normal practice, work started with the ceiling, progressed to the fireplace wall with the portraits of Ludovico and Barbara of

Brandenberg with their children and servants, then progressed around the room in a clockwise direction, ending on the wall by which visitors enter today, with its depictions of Ludovico greeting his son Cardinal Francesco Gonzaga. Mantegna's obsessive insistence on descriptive detail and surface refinement meant that nine years elapsed from start to finish, during which time children grew, courtiers were replaced or died, foreign relations such as King Christian I paid visits, and adults aged. Accordingly, the commission was adapted to meet these changing circumstances. What remained constant and what, today, still gives resonance to the figures, some of which are severely damaged, is the architectural setting. A proper appreciation of the room should begin with this tour de force of illusionism—among the first and certainly the most ambitious illusionistic interior since antiquity:[19] the forerunner of Veronese's celebrated work at the Palladian Villa Barbaro near Asolo in the sixteenth century and of Tiepolo's great frescoes in the Palazzo Labia, in Venice, in the eighteenth (following custom from the sixteenth century on, Tiepolo employed a specialist in perspective, Girolamo Menegozzi-Colonna, to paint the architecture).

The room itself is modest in size. It measures twenty-six and a half feet square with a vaulted ceiling twenty-three feet high. The principal wall has a slightly off-center fireplace and, to its left, a deep-set window. A second window, overlooking a lake with the Ponte di San Giorgio, is awkwardly positioned beneath a bracket capital on an adjacent wall. The remaining walls have a single door—one in the corner, the other off-center—and storage niches. The architectural features—the bracket capitals, door frames, and carved fireplace mantle—are in Renaissance style and cannot much predate the frescoes. Although more intimate and stylish than the Ovetari Chapel, the room was still essentially a shell waiting for an identity.

Mantegna's solution was both simple and ingenious. His point of departure was the existing architecture, and his first task was to accommodate his cycle to it. The bracket capitals became three-dimensional elements of painted pilasters positioned on an elaborate fictive dado of colored marbles. Painted ribbed arches connect the pilasters, transforming the lunettes into an arcade, and other painted ribs extend across the vault, dividing the ceiling into compartments richly decorated with simulated marble or stucco reliefs and garlands against a simulated gold mosaic background. At the center of the vault an *oculus* with a balustrade of interlocked marble rings viewed in steep foreshortening offers an illusionistic view to the sky. On two of the walls fictive brocade curtains suspended from rods between the painted pilasters close off the arcade openings, but on the other two walls the curtains have been drawn back to provide views of an idyllic landscape

and an elevated, walled garden enclosure, the height of which is only slightly above the mantle of the fireplace. The mantle itself projects just below one of two painted Anatolian carpets that hang over the edge of a platform on which various courtiers stand. Heavy garlands of naturalistic fruit are shown encircling the *oculus* and suspended from the crown of arches of the arcade, where medallions decorated with Gonzaga heraldic devices and mottoes also hang (like the curtains, some of the medallions have become little more than blurred shapes). By this ingenious system, Mantegna transformed what had been an enclosed room in a damp tower into an airy pavillion in which the inclement weather of Mantua has been banished and a perpetual spring smiles on the Gonzaga court.

Even without the portraits this room would rank as one of the great achievements of Renaissance painting, and it is worth underscoring the subtle ways Mantegna incorporated existing features of the room to assure that the illusion would be both consistent and convincing. For example, to the left of the scene of Ludovico and his court, Mantegna showed a curtain slightly drawn back, its form interrupted by the recessed window. Above the window are two hooks from which, originally, a real curtain would have been hung, and there can be little doubt that Mantegna counted on the real curtain to augment the illusion of his own. This window is one of the two in the room, and the lighting on the painted busts of Roman emperors on the ceiling was calculated to take these two different sources into account, varying in intensity depending upon the proximity of the sculptural decoration to one or the other of the windows. However, the light that illuminates the *oculus* comes from neither window. Rather, it is imagined as the bright sunlight of the sky depicted above, so that a deliberate contrast is made between a soft, bidirectional interior light and a more dispersed and brilliant exterior one. The distinction is maintained on the walls of the room, where we find that the figures standing beneath the painted arcade, and therefore close to the viewer, are lit from the actual windows, while the background landscape is bathed in a beautifully diffuse, seemingly natural daylight falling from the opposite angle—the same angle as in the *oculus* above. This subtle device greatly enhances the fiction of the viewer sharing with the Gonzaga family the same enclosed, free-standing, ancient-styled pavillion, shielded from the sun by closed curtains. Optical verity is more frequently associated with Piero della Francesca or Giovanni Bellini than with Mantegna, but when an illusion depended on effects of light, Mantegna was second to none.

A good deal of research has focused on the possible Roman sources for Mantegna's invention, including the suggestion that—presumably on Alberti's advice—he had in mind the Pantheon, with

its open *oculus*, or the atrium of a Roman house as described by Vitruvius.[20] It has also been suggested that the room is a realization in paint of one of the temporary pavillions then constructed on special occasions—weddings and feast days—to protect guests.[21] It would be foolish to think that Mantegna did not avail himself of Alberti's unsurpassed knowledge of Roman architecture in creating the room, but at the same time its form was dictated by the existing architecture, while details such as the trompe l'oeil *oculus* were first and foremost a demonstration of Mantegna's creative genius. (For Alberti, the principal component in the "true and correct ornament of building . . . is not the outlay of wealth but the wealth of ingenuity."[22]) In Mantegna's hands decorative opulence—the simulated gold mosaics, marble, stucco carvings, and brocade curtains—was restrained by architectural or archeological concerns: dignity and decorum balanced the more traditional courtly aesthetic of ornamental richness and magnificence, and together these elements sustain an illusion. That illusion concerns the apparent reality of the figures inhabiting this imaginary space.

Ludovico's family and court are portrayed carrying out the everyday tasks of governing the state of Mantua. On one wall, Ludovico sits on an elaborate chair beneath which his dog Rubino has comfortably positioned himself. A messenger wearing Gonzaga livery has arrived; he stands in front of a pilaster and so establishes both the projection of the elevated platform in front of the picture plane and the position of Ludovico and Barbara in front of the arcade. Hat in hand, he has evidently handed Ludovico a letter and now stoops to receive the marquis's reply. The marchioness looks up from her daughter to weigh the import of the—evidently—serious missive, while figures in the background seem interested in other matters. (They are depicted lower in the picture field, since, as in the fresco of *St. James Blessing the Scribe Josias* in the Ovetari Chapel, Mantegna rigorously projected the scene from the viewer's *di sotto in sù* position.) To the right, more figures in Gonzaga livery, some holding their gloves (a sign of their importance), arrive, and one of these, at the far right, acts as an Albertian choric figure by looking out of the fresco and into the room at the viewer—a sort of interlocuter. The basis of all future conversation portraits is here both established and mastered.

On the adjacent wall no enclosure blocks the view of an idyllic—and certainly not topographical—landscape: a romantic evocation combining contemporary architecture with archeological monuments. This is the Gonzaga state (one of the gates bears the Gonzaga coat of arms), imagined not as the tapestry world of chivalric myth, such as Pisanello might have evoked for Ludovico's father, but as classical fantasy. Like Veronese a century later, Mantegna may have been inspired

by Pliny's description of ancient Roman villas decorated with views of gardens, hills, groves, and the like. To the left of one of the actual doors of the room stand Ludovico's grooms with his dogs and one of his horses, while to the right the marquis raises his hand to greet his son Cardinal Francesco Gonzaga, who holds the hand of his younger brother Ludovico, already a papal protonotary and Bishop Elect of Mantua at the age of nine. In turn, the young Ludovico clasps the hand of his nephew Sigismondo, who was also destined to an ecclesiastical career. Mantegna depicted the marquis's heir, Federico, to the right, in profile (a pose associated with princely portraits), while the child standing next to the marquis and wearing a cloak with green sleeves bears the distinctive features of Federico's eldest son, Francesco, who was to succeed his father and marry Isabella d'Este. Clearly, this is a dynastic group portrait, and as such it includes depictions of King Christian I and Emperor Frederick III in the background.

So successful was Mantegna in creating an impression of actuality that the viewer might be tempted to identify the two scenes with known historical incidents.[23] Mantegna obviously intended to evoke court life at Mantua, but the "events" he portrayed are fictional. Nor should we burden the frescoes with overly erudite meaning. The appearance on the vault of the first eight Caesars and the labors of Hercules was a topos of rulership. Moreover, portions of the decora-

tion signal the same light, witty touch found in the Ovetari Chapel. The putti struggling to support the dedicatory inscription, with its obvious false modesty, would not suit the depiction of a historical scene. And the implausible mixture of putti and servants who cast their bemused gazes upon the viewer from the *oculus* demonstrate that Mantegna primarily intended the frescoes to give pleasure—albeit of a very sophisticated order—both to its occupant (who must frequently have gazed at the ceiling from his bed) and to the dignitaries who were, we know from documents, shown the room as part of a state visit.

Who are these figures in the *oculus* and what are they doing? The figures grouped around roughly one third of the balustrade appear to be servants; they look down mischievously as one—elaborately coiffed and conceivably a family relation—averts her eyes in dissimulation as she places her hand on a rod supporting a precariously propped tub of citrus. She is evidently egged on by her grinning African attendant. The threat is as obvious as it is playful. The other two thirds of the balustrade is occupied by a band of winged putti who are up to no good. One has his head stuck in an opening of the ballustrade. Another threatens to drop an apple on the viewer's head—a motif reminiscent of the peeing putto in the Ovetari Chapel. One brandishes either a stick or, more likely, a peashooter, perhaps planning an attack on the Gonzaga's haughty peacock. Near the African slave a putto

pertly crowns himself with a laurel wreath. These details were meant to amuse and, in so doing, to arouse admiration, a well-established concept in Mantegna's day. In 1456 the humanist Bartolomeo Fazio had praised a mural by Pisanello in the Doge's Palace in Venice for its depiction of "a priest distorting his face with his fingers, and some boys laughing at this, done so agreeably as to arouse good humor in those who look at it."[24] And Alberti had declared that in decorating a private residence, "I am delighted by anything that combines ingenuity with grace and wit." (He particularly admired "the representation of stone colonnading" for wall decoration).[25] Mantegna included yet another detail—today almost effaced—for such a learned viewer: just above the tub of citrus the clouds have taken on the momentary form of a head in profile, in conformity with the observations of various ancient authors and of Alberti that nature creates chance images (Mantegna made this a frequent feature in his painting, well aware of the recognition it would receive).[26]

No less than the Ovetari Chapel, the *Camera Picta* is a watershed of the Renaissance imagination. Henceforth, a trompe l'oeil opening on the ceiling with servants or courtiers looking down was almost essential for princely chambers, and in Mantua itself, Giulio Romano took the invention to its comical conclusion, creating in the Palazzo Tè a scene of the marriage of Cupid and Psyche in which the viewer looks up the legs of the couple, who extend their arms over the opening. What in Mantegna is lighthearted becomes in Giulio's hand a coarse guffaw. But then, Giulio—a born trickster—did not possess Mantegna's "exalted and bright genius," a genius—abundantly evident in both the Ovetari Chapel and in the *Camera Picta*—that his patrons and friends deeply admired. Writing to Mantegna in 1489 about a series of canvases showing the triumphs of Caesar (now at Hampton Court), left unfinished when the artist went to Rome to work for the pope, Marquis Francesco noted that "they are works from your hand and genius, but we glory in them by having them in our possession,"[27] and three years later, in an honorific decree granting Mantegna land, the marquis specifically cited among those works that had accrued to the greater glory of the Gonzaga the *Camera Picta* created for his grandfather. We are a far cry from the days when a court artist might expect to be treated like a lackey and his work appreciated primarily for its craftsmanship, or when an irritating patron such as Imperatrice Forzate could carp at the number of apostles shown in a scene of the Assumption of the Virgin. Henceforth, it was the creative genius of the artist (what contemporaries increasingly referred to as his "fantasia" or "ingenio") that was prized. Through genius, the work of art acquired an aura in whose light a patron might hope to bask.

Notes

1 The duke's opinion is cited in a letter published by R. Signorini, *Opus hoc tenue: La Camera dipinta di Andrea Mantegna*, Mantua, 1985, pp. 305-06, doc. 23.

2 The commission dates from 1315, but Simone was required to redo parts of the mural in 1320, at which time a number of heads and hands were added on newly laid areas of plaster. A fine summary of the technical information is in E. Borsook, *The Mural Painters of Tuscany*, 2d ed., Oxford, 1980, pp. 20-21.

3 The most readable account of Pisanello's practice as a mural painter is J. Woods-Marsden, *The Gonzaga of Mantua and Pisanello's Arthurian Frescoes*, Princeton, 1988, pp. 108-14. She is principally concerned with the cycle of frescoes done for the Gonzaga at Mantua, but the comments are equally relevant to Pisanello's work at Sant'Anastasia and San Fermo.

4 The identity of Antonio Ovetari's wife as a member of the noble Forzate family has been established by Keith Shaw, who has kindly made his thesis available to me (see bibliography).

5 This is convincingly argued by Keith Shaw in his thesis.

6 Although the terra cotta altarpiece was commissioned from both Pizzolo and Mantegna, it was Pizzolo who had experience as a sculptor, and in 1449 he was assigned exclusive responsibility for it. He seems to have enlisted the collaboration of another assistant of Donatello, Giovanni da Pisa, to whom payments for the altarpiece—conceivably for the marble framework—were made. The altarpiece is a key work in the history of northern Italian Renaissance sculpture and deserves separate attention. It is my view that many of the illusionistic devices that appear in the frescoes were initially explored in the altarpiece, which displays full grasp of Donatello's innovative use of pictorial space to heighten the dramatic impact of the scenes. There is, in any event, a complete unity of approach between the altarpiece and the frescoes, underscoring the crucial role Pizzolo had in giving direction to the Ovetari scheme as a whole.

7 A destroyed altarpiece painted in 1448 is recorded as having had an inscription giving Mantegna's age as seventeen, but the validity of the inscription has been contested; for a summary of the views, see the exhibition catalog, *Andrea Mantegna*, Royal Academy, London, and the Metropolitan Museum of Art, New York, 1992, pp. 99, 112, note 38.

8 The words are those of Giovanni Santi, the father of Raphael and a painter at the court of Urbino. According to Santi, Federigo da Montefeltro was speechless when he first saw Mantegna's work at Mantua, and Santi himself praised

Mantegna as the greatest artist of his day, noting in his rhymed chronicle Mantegna's "alto ingegno e chiar"; see Kristeller, 1902, p. 493, for the relevant passage. The judgment is especially interesting in that it comes from someone who personally knew Piero della Francesca.

9 B. Fazio, "De pictoribus," in *De viris illustribus*, 1456, as translated by M. Baxandall in *Giotto and the Orators*, Oxford, 1971, rept. ed., 1991, p. 103. Baxandall provides the best account of the relation of humanist criticism to Renaissance style.

10 By the mid-1400s there was an emerging sense of decorum that began to insist on decking out ancient stories with plausibly historical costumes and settings. Perhaps the most famous, if misdirected, comment in this regard is that of the Florentine sculptor Antonio Filarete, who in his treatise on architecture chastised Donatello for showing the Paduan soldier Gattamelata in ancient rather than modern dress. Filarete then commented on the fact that artists would be no less wrong to show Caesar and Hannibal in modern garb. Mantegna was among the earliest artists to make his work historically plausible, within the restrictions of his time.

11 Cicero, *De Oratore*, II, lvix, 220-21, trans. H. Rackham, Cambridge (Loeb Classical Library), 1942, p. 177.

12 L. B. Alberti, *De pictura*, 1435, II, 44, ed. C. Grayson, London, 1972, p. 85.

13 Quintillian, *Institutio oratoria*, trans. H. E. Butler, London and New York (Loeb Classical Library), 1921, II, xiii, 8-12.

14 *Ibid.*, xvii, 21.

15 Cicero, *op. cit.*, p. 15.

16 Alberti, *op. cit.*, p. 83.

17 On these cycles, see E. S. Welch, "Galeazzo Maria Sforza and the Castello di Pavia, 1469," *Art Bulletin* 71 (1989): pp. 351-75, and *idem.*, "The Image of a Fifteenth-Century Court: Secular Frescoes for the Castello di Porta Giovia, Milan," *Journal of the Warburg and Courtauld Institutes* 53 (1990): pp. 163-84.

18 R. Signorini, *op. cit.*, has pointed out that June 16, 1465, was the second Sunday after Pentecost (Easter is, of course, a movable feast day, as is Pentecost). Ludovico was born on June 5, 1412, also the second Sunday after Pentecost, and Pius II arrived in Mantua on May 27, 1459—again the second Sunday after Pentecost. Fifteenth-century patrons were obsessed with astrology, and the date Mantegna shows was obviously not simply the day he began work.

19 The most important earlier illusionistic interior was Andrea del Castagno's fresco decorations for the Villa Carducci at Legnaia (a suburb of Florence). Painted around 1449, the frescoes were detached in 1847. Today it is almost impossible to appreciate

the original effect of the shallow loggia with famous men and women and, above, groups of dancing putti holding swags. Castagno did not attempt the sort of landscape views or any complex integration of actual and simulated architecture. Nor did the decoration extend to the ceiling, which was coffered. Also of interest is the feigned architectural decoraton of the *Biblioteca Greca* in the Vatican, the date and attribution of which, however, is highly uncertain (it has been ascribed to Andrea del Castagno).

20 Vitruvius, *The Ten Books on Architecture*, IV, iii, trans. by M. Morgan, Cambridge, 1914, pp. 176-77.

21 This is argued by E. Welles, "A New Source for the Architecture of Mantegna's *Camera degli Sposi*," *Source*, II, 2, 1983, pp. 10-15.

22 L. B. Alberti, *On the Art of Building in Ten Books*, IX, 1, trans. by J. Rykwert, N. Leach, R. Tavernor, Cambridge, 1988, p. 292.

23 The literature regarding this is considerable. A convenient summary of views and a sage interpretation is presented by R. Lightbown, *Mantegna*, Oxford, 1986, pp. 107-08; 111-12.

24 B. Fazio, *De viris illustribus*, as translated by M. Baxandall, *op. cit.*, p. 107.

25 L. B. Alberti, *op. cit.*, IX, 4, trans. by J. Rykwert, N. Leach, R. Tavernor, Cambridge, 1989, p. 298.

26 The most detailed article on this subject is H. W. Janson, "The 'Image Made by Chance' in Renaissance Thought," *De artibus opuscula XL: Essays in Honor of Erwin Panofsky*, ed. M. Meiss, New York, 1961, pp. 254-66; reprinted in H. W. Janson, *16 Studies*, New York, 1973, pp. 55-69. Aristotle, Pliny, and Lucretius all mention images in clouds, but the most interesting is in Philostratus's *Apollonius of Tyana*, in which the relation of such chance images to the willful ones of painters is discussed as well as the relation of the painter's imagination to that of the viewer. These are perceptual games Mantegna would have greatly enjoyed. His earliest picture to include a cloud-image is the *Saint Sebastian* in the Kunsthistorisches Museum, Vienna. The picture is, uniquely, signed in Greek, and was obviously destined for a sophisticated patron capable of recognizing the many, playful allusions Mantegna introduced.

27 See P. O. Kristeller, *Andrea Mantegna*, Berlin and Leipzig, 1902, document 103, p. 546.

Opposite: The Church of the Eremitani, Padua

Plates and Commentaries

Part I: The Ovetari Chapel, Padua

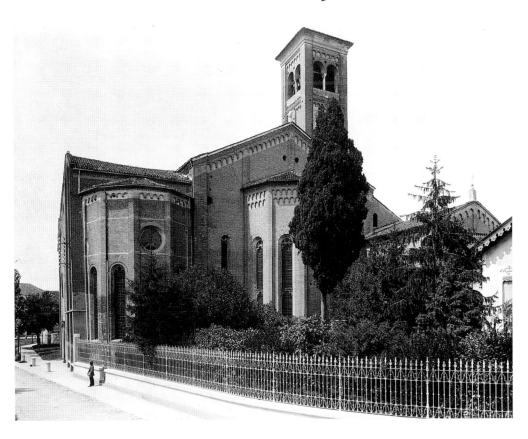

Diagram of the Ovetari Chapel

The Ovetari Chapel is divided by an arch into two spaces. The apse was decorated by one of the geniuses of northern Italian painting, Niccolò Pizzolo (a?, c, f-i), and by the young Mantegna (b, d, e, j). It contained a free-standing altar with a terra cotta altarpiece designed and executed at least in part by Pizzolo. The main part of the chapel contained two fresco cycles on facing walls. That on the left was by Mantegna and showed the life of the apostle St. James the Greater (o-t). That on the right was frescoed with the life of St. Christopher (u-z) by four artists, three of whom can be identified with certainty as Bono da Ferrara (w), Ansuino da Forlì (x, v?), and Mantegna (y, z); the fourth artist may have been Girolamo di Giovanni of the Marchigian town of Camerino (u). The vault bore depictions of the four evangelists painted by the Venetian team of Giovanni d'Alemagna and Antonio Vivarini (k-n). By employing a group of artists, it was hoped that the chapel could be frescoed within two years; in fact it took nine, and only Mantegna worked on it from start to finish. In selecting the scenes for the lives of the two saints an obvious effort was made to establish correlations among the incidents of their lives as passed down in standard hagiographic sources. This was a common concern in the fifteenth century, and it accounts for the elimination of some episodes normally encountered in fresco cycles devoted to these saints and the inclusion of others. It is notable that no posthumous miracles of either saint were included. The subjects of the frescoes and their respective authors are as follows:

a. St. James the Greater (Pizzolo?)

b. St. Peter (Mantegna)

c. God the Father (Pizzolo)

d. St. Paul (Mantegna)

e. St. Christopher (Mantegna)

f-i. The four Church Fathers: Jerome, Augustine (?), Gregory the Great, Ambrose (?) (Pizzolo)

j. Assumption of the Virgin (Mantegna)

k-n. The four evangelists: Mark, Matthew, Luke, and John (Giovanni d'Alemagna and Antonio Vivarini)

o. The Calling of Sts. James and John (Mantegna)

p. St. James Disputing with the Demons (Mantegna)

q. St. James Baptizing Hermogenes (Mantegna)

r. St. James Before Herod Agrippa (Mantegna)

s. St. James Led to Execution (Mantegna)

t. The Execution of St. James (Mantegna)

u. St. Christopher before the King of Canaan (Girolamo di Giovanni da Camerino?)

v. St. Christopher Encounters the Devil (Ansuino da Forlì?)

w. St. Christopher Carrying the Christ Child (Bono da Ferrara)

x. The Arrest of St. Christopher (Ansuino da Forlì)

y. The Attempted Martyrdom of St. Christopher (Mantegna)

z. St. Christopher Beheaded (Mantegna)

*. Altarpiece (Niccolò Pizzolo and Giovanni da Pisa)

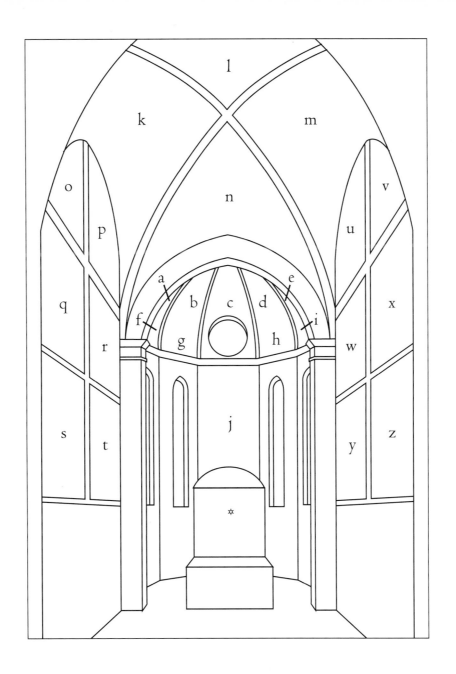

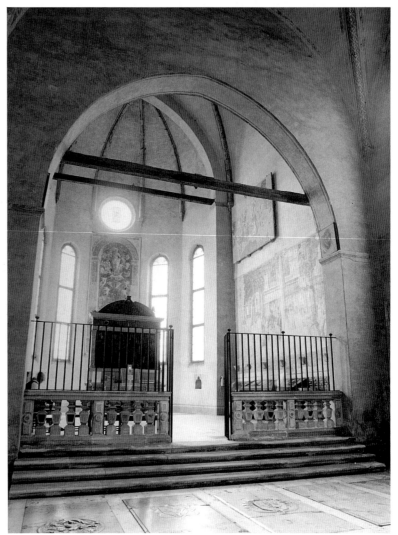

Views of the Ovetari Chapel before and after World War II

The Ovetari Chapel was destroyed by an allied bomb in World War II and has been reconstructed. In its present form it preserves two frescoes by Mantegna, the *Assumption of the Virgin* and *The Attempted Martyrdom of St. Christopher and St. Christopher Beheaded*, that had been detached from the walls in the nineteenth century for reasons of conservation, as well as the terra cotta altarpiece, which was reassembled after the war from fragments salvaged from the wreckage. Essentially, however, we see the chapel the way Mantegna and his co-workers did, with bare walls and an almost nondescript Gothic architecture. In all likelihood the circular window was specially built in the fifteenth century to allow better light for the anticipated fresco decoration and as a way of creating a surface behind the altar for the *Assumption of the Virgin* on the central axis of the chapel. Pizzolo and Mantegna set about to give the chapel an architectural character it did not otherwise possess, and to a degree their frescoes can be viewed as subservient to this overall scheme. Their success can be judged by the photo of the frescoes as they appeared before World War II. Illusionism was the keynote: it is enough to note that the architectural surround of the *Assumption of the Virgin* was repeated around each of the tall windows and that the images of the four church fathers were conceived to match the circular window. Thus, a play was set up between actual and fictive windows: the first admitting light, the latter providing views into imagined scenes. The same mentality lies behind the framework of the twin cycles of Sts. James and Christopher.

(opposite, left and right)

St. Peter, God the Father, St. Paul, and St. Christopher

Mantegna and Pizzolo began their work on the vault of the apse and had almost completed their figures of God the Father accompanied by saints by late summer 1449. They intended the figures to appear miraculously in the sky behind stone ribs from which heavy garlands of fruit were hung. The fictive stonework was done in monochrome, while the garlands employed brilliant color to enhance the contrast. The figures were quite obviously studied from lathe figures draped in wet or sized cloth, and this accounts for the remarkable clinging folds of the drapery. It was a technique pioneered by Donatello and doubtless learned from him by his assistant Pizzolo, who passed on the technique to Mantegna. Sixteenth-century critics were aware of Mantegna's use of such models, which, indeed, became part of standard academic practice down to the mid-nineteenth century.

The two patron saints of the chapel appeared at the extremities, near the cycles of their lives, while the two principal apostles, Peter and Paul, stood next to God the Father. The St. James was already badly damaged by the late nineteenth century, and its authorship is unclear from the documents. The simulated carved moldings of the ribs of the apse were complemented by the decoration of the underside of the dividing arch with a series of interlocking oval frames, behind which appeared half-length figures of cherubim and seraphim (partly visible in the *St. Christopher*). The outer face of the arch was decorated with a classical bucrania motif (bull's head with garlands) and, at either base, over-life-size marble busts of Mantegna and Pizzolo.

(pages 44-45, left to right)

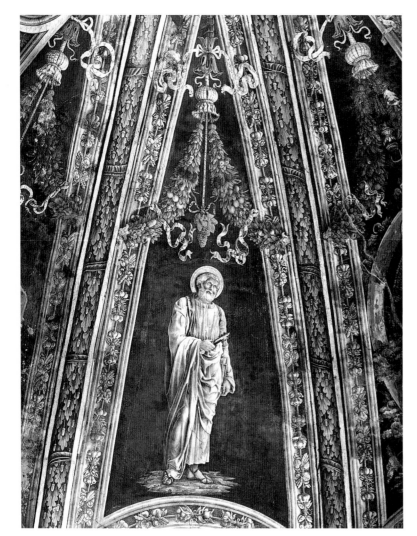

St. Peter

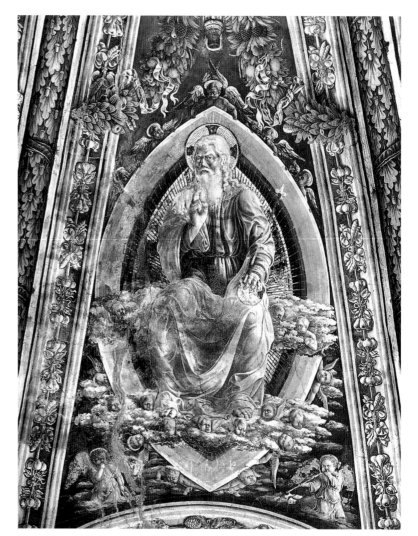

God the Father

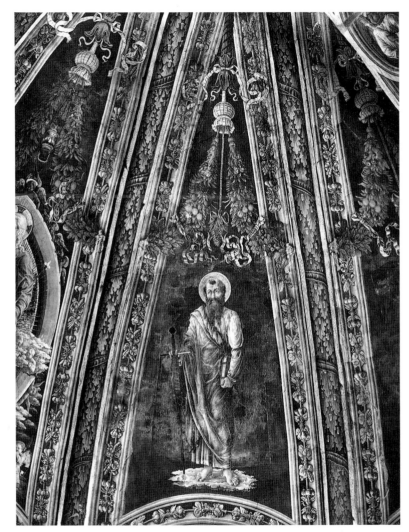

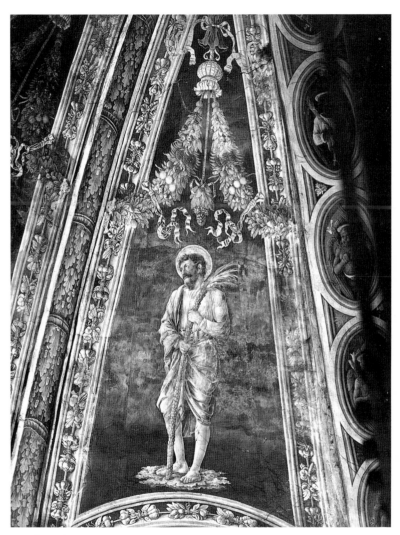

St. Paul *St. Christopher*

The Church Fathers

Pizzolo depicted the four church fathers in the lunettes of the apsidal vault, two to either side of a circular window (the pair in best condition before World War II is illustrated at right). Shown as though viewed through giant, recessed windows, they ranked among the great inventions of fifteenth-century painting and were widely imitated. Pizzolo's use of the actual predominant light source in the chapel to cast one side of the fictive window embrasure into shadow was especially effective in creating a sense of three-dimensionality, as was the rich and varied decoration—either simulated carving or inlaid marble. Within the studies the ceilings, viewed from below in steep foreshortening, emphasized the spatial depth, itself further enhanced by details such as the open doors of cabinets filled with books, projecting lecterns, or an inkwell and paper hanging over a desk. The prominently veined wood of the desks underscored the assertive realism of Pizzolo's style, as did the artist's attention to such minor details as the attachment of the ornamental garlands surrounding the openings by means of simulated iron rings. The architectural molding below the fictive *oculi* was also trompe l'oeil.

Some years earlier Donatello had created fictive *oculi* in Brunelleschi's Old Sacristy of San Lorenzo in Florence to frame scenes from the life of St. John, and he was later to use the same device to frame an image of the Madonna and Child for the Cathedral of Siena. Presumably Pizzolo was indebted to him for the illusionism he employed, but it should also be kept in mind that according to later sources he had worked in a chapel in the Palazzo del Podestà in Padua frescoed by the Florentine Filippo Lippi, who worked there in the mid-1430s. Veneration of the four church fathers—those early theologians who established the basis of church orthodoxy—was popular in northern Italy, especially in a university city like Padua. Their appeal to a lawyer like Giovanni Francesco Capodolista, who was among Ovetari's executors, is obvious. However, there was no precedent for the arrangement envisaged by Pizzolo, which grew out of his response to the architectural peculiarities of the chapel.

[*Pope Gregory the Great*, opposite left; *St. Ambrose* (?), opposite right]

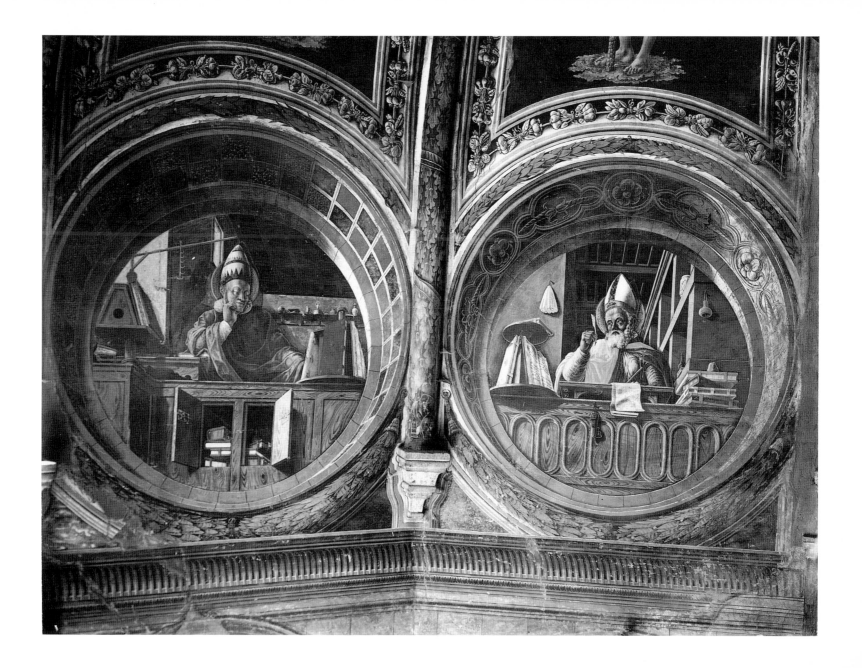

The Calling of Sts. James and John and St. James Disputing with the Demons

Mantegna's first fully independent frescoes, following his break with Pizzolo in September 1449, were these two scenes of Christ calling St. James and his younger brother John, and *St. James Disputing with the Demons*. The first story (on the left) is Biblical (Matthew 4:21, Mark 1:19, and Luke 5:10). Jesus, accompanied by Peter and his brother Andrew, who had just abandoned their fishing nets to become apostles, gestures to James and John, inviting them to become fishers of men. "And they immediately left the ship and their father [Zebedee], and followed him." Mantegna envisaged the Sea of Galilee surrounded by fantastical rocky cliffs with, in the distance, a medieval walled city. A palm tree provided reference to Palestine, while Zebedee was shown at work in his boat. By comparison with the later scenes, the figures are rustic in appearance—their poses reflect Mantegna's close study of Donatello's work on his altarpiece for the church of the Santo in Padua during these years—and it is not surprising to learn that before documents were discovered specifying the authorship of this scene and its companion, the attribution to Mantegna was doubted. A plant peculiar to the eastern Mediterranean, the dragon arum, or *Drancunculus vulgaris*, appears in the painted stone framework dividing the two scenes—further evidence of Mantegna's intense intellectual curiosity.

The second scene (on the right) is based on medieval legend. The magician Hermogenes sent his disciple Filetus to convict James of false doctrine. Instead, Filetus was converted by James's preaching and urged his master to do the same. The enraged Hermogenes sent demons to bind James, but they were powerless against him. After questioning them, the apostle charged the demons to bring Hermogenes to him, which they did; Hermogenes was eventually also converted. In the interest of concision, Mantegna compressed two episodes normally given separate treatment—James preaching and James with the demons—and eliminated other traditional episodes, such as the freeing of Hermogenes from his bonds. The key point was to create a counterpart to the corresponding episode from the life of St. Christopher on the opposite wall, showing the saint meeting the Devil. As a means toward narrative unity, Mantegna made some of his listeners react to the presence of the demons with gestures of fear and dismay.

The background architecture is the earliest indication of Mantegna's interest in archeological fragments, said to have been fostered in the workshop of his teacher, Francesco Squarcione. In actuality, Squarcione's importance has certainly been exaggerated, and Mantegna's understanding of ancient and Renaissance architecture at this point was obviously rudimentary. Classical architecture provided him above all with decorative motifs rather than structural forms. Nonetheless, in the face carved into a medallion above the ill-proportioned door and in the putto scrambling up the garland suspended in front of the scene there is a taste of Mantegna's humorous wit: both seem to react to the presence of the goat-eared demons. The figures on the right side are probably by an assistant of Mantegna.

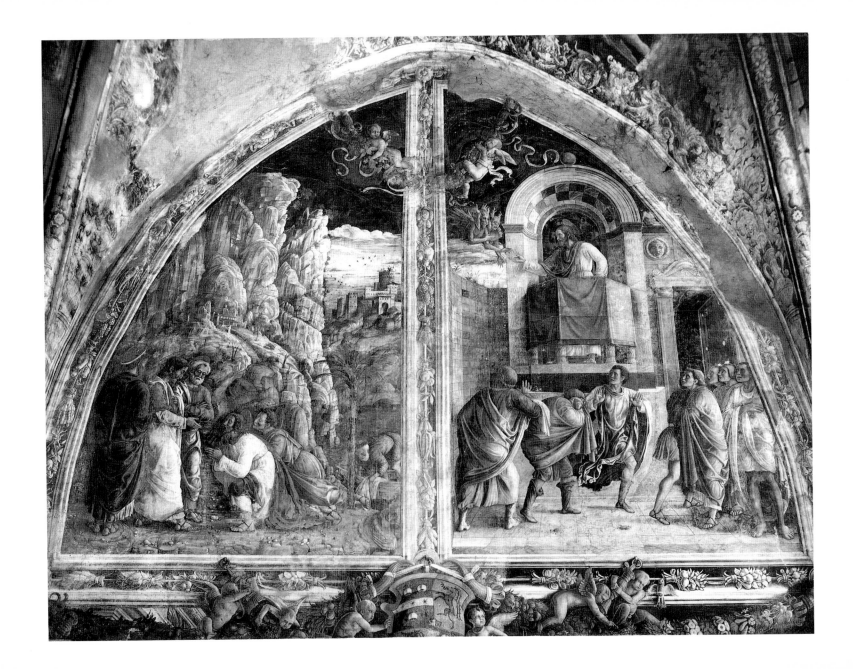

St. James Baptizing Hermogenes and St. James Before Herod Agrippa

The complementary scenes of *St. James Baptizing Hermogenes* following the magician's conversion and the trial of the apostle by Herod Agrippa are the first mature statements of Mantegna's art. Although they are independent episodes in the saint's life, the perspective of the two scenes shares a single central vanishing point, and a viewer might be excused for believing that the square in which Hermogenes is baptized is the same in which Herod's throne has been erected. In point of fact, the shadows of a crenellated wall marking the confines of the marketplace are visible on the pavement of the left-hand scene. The contrast of the svelt, elegantly attired figures with their rugged counterparts in the scenes above could not be more dramatic, and it is astonishing that the frescoes are separated by perhaps less than a year, underscoring the rapid growth of the artist, who may have been no more than twenty at this time.

In the first scene, set in Mantegna's interpretation of an ancient marketplace (the man in the background behind the archway is either a druggist or a vendor of ceramics), the apostle pours a thin stream of water onto the balding head of the repentant Hermogenes. The magician's books of spells lie in a heap, ready to be thrown into the sea, but one bystander—evidently a man of learning, to judge from his clothes—has picked up one for inspection. Mantegna has filled out the scene with a youth caring for his infant sibling. The architecture shows enormous advances over the scene above. Most of the motifs were studied from the Roman monuments of Verona or from drawings after antiquities. By this date Mantegna may already have established a close relationship with the leading Venetian painter Jacopo Bellini, whose daughter Nicolosia he would marry in 1453. Jacopo had close ties with the court of Ferrara and was an avid student of ancient scupture, coins, and intaglios.

The second scene shows James's trial by the Jewish King Herod Agrippa, who, according the the Acts of the Apostles (12:2), "killed James, the brother of John, with the sword," as part of his persecution of the new Christian movement. This laconic report was not further elaborated upon in Jacobus de Voragine's immensely popular *Golden Legend*, written in the thirteenth century, and the apostle's trial was not usually illustrated in cycles of his life. This left Mantegna free reign. He has imagined Herod as a Roman ruler (and, indeed, Herod had been appointed by the Romans), seated on a throne decorated with a sphynx modeled directly from an ancient sculptural fragment in Verona. An imperial baldachin, such as appears on Roman coins, is supported above him, much like an umbrella, and is surmounted by a statuette of Victory. The triumphal arch, perhaps patterned on that at Pola, is used as a scenographic backdrop and to contrast the pagan world—pointedly alluded to by the sacrificial relief—to the apostle's imminent Christian victory through martyrdom. The inscription is from the ancient tomb of T. Pullius Linus near Padua and was much copied by antiquarians as well as by Jacopo Bellini. The putti above play with a tethered owl—again, a witty allusion to the shackled saint. The Roman soldier at the left is a self-portrait of Mantegna.

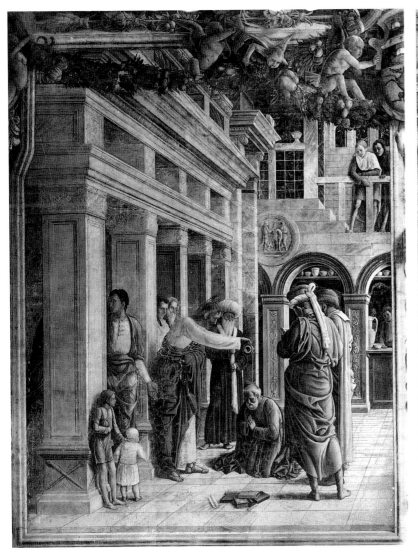
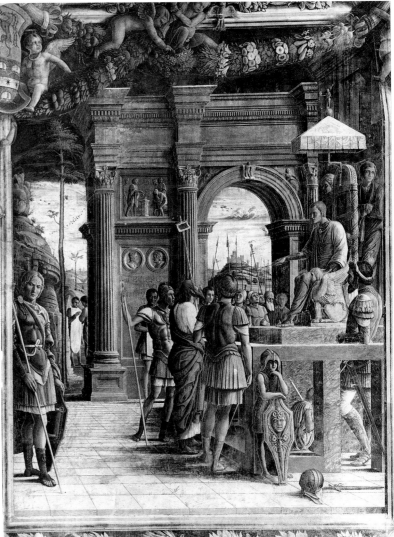

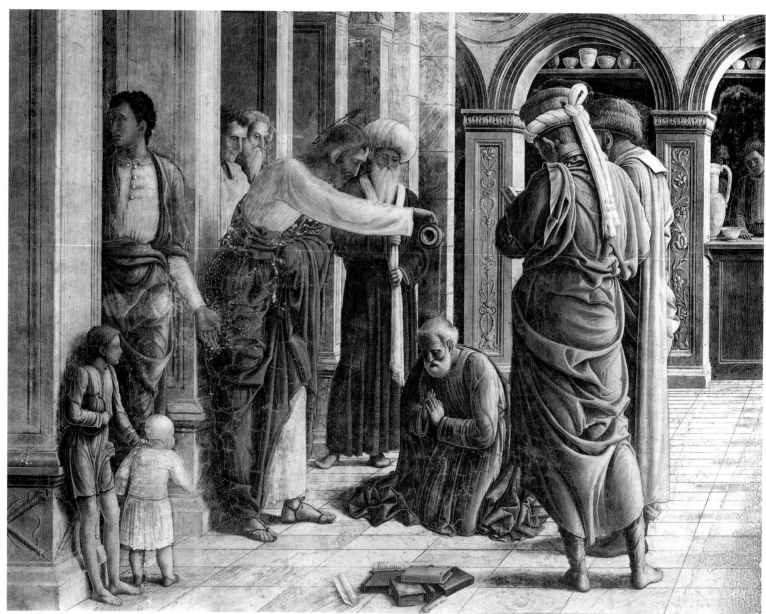

Detail, *St. James Baptizing Hermogenes*

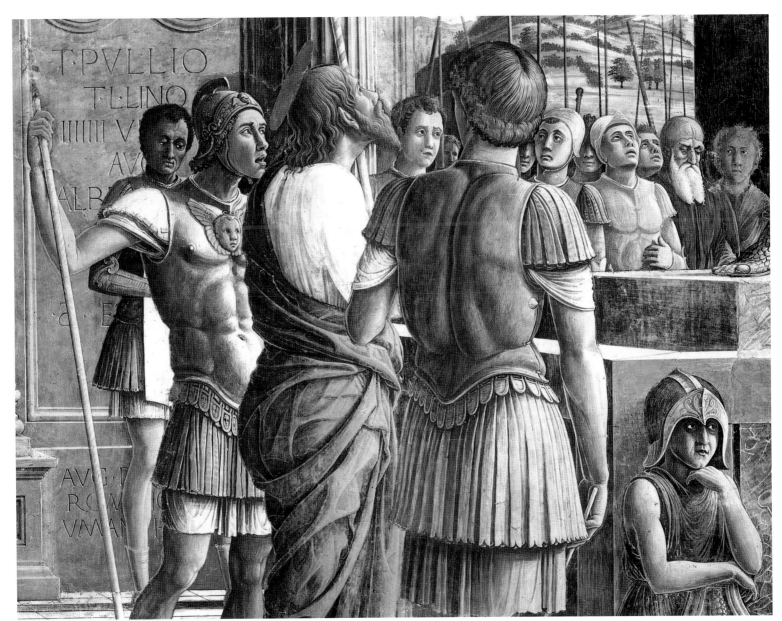

Detail, *St. James Before Herod Agrippa*

St. James Led to Execution
and The Execution of St. James

Mantegna's art reached a high point of narrative subtlety in the final two scenes of the story of St. James: his blessing of the repentant scribe Josias as he was led to execution and his decapitation. The viewpoint in both is low—approximately that of an actual viewer in the chapel. In the left-hand scene the ground plane drops away so that we see the undersides of the feet of the figures in the foreground. Some of the figures project into the viewer's space, their toes or heels shown hanging over the edge of the scene. The precipitous lines of the houses—medieval in style but in one case incorporating a Roman relief—and the agitated standard, topped by jostling scales of justice (a typically ironic comment by Mantegna), help accentuate the dramatic tension. To the left, soldiers look on in astonishment as James halts on his way to his execution to bless Josias—identified by the pen holder that hangs from his belt and marvelously characterized by the holes in the soles of his shoes (a terse social comment a century and a half before Caravaggio). Josias had been converted when he saw James heal a lame man. To the right, a crowd-controlling soldier confronts an enraged priest, who delivers the soldier a knee-kick to the groin. The triumphal arch, with its windowed second story, is based on the Porta Borsari in Verona, though the inscription in a medallion is copied from another arch, the Arco dei Gavi, also in Verona and celebrated as the work of the famous Roman architect Vitruvius.

Mantegna has, however, freely invented, and his arch is anything but archeologically correct.

In the second scene Mantegna shows a decapitation not with a sword but with a small guillotine (this was, again, a novel interpretation evidently admired by antiquarians, since the motif occurs in a manuscript collection of ancient monuments and inscriptions compiled by Mantegna's friend Felice Feliciano). The coarse realism of Mantegna's early work has here been replaced by a sublime intellectualism: James's head is made to appear as though projecting into the viewer's space, beyond the railing attached to the outside of the picture frame (his body is a tour de force of foreshortening). The horse on the right is used to engage the viewer's attention, and the character of the executioner is marvelously described through costume and facial features; in straining to wield his mallet he has split open the seams of his shirt. The landscape setting is a study of deterioration and collapse, from the monument at the right, eaten away by protruding roots, to the fortress in the background, split open. The arch is, again, inspired by a monument in Verona, the Porta Leoni, which much fascinated later architects, such as Serlio and Palladio. The broken branch is surely a comment on the apostle's decapitation, and the owl perched in a barren branch at the upper right must also carry some meaning, now hidden to us.

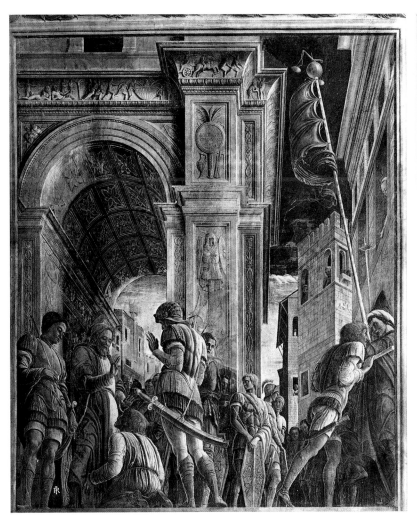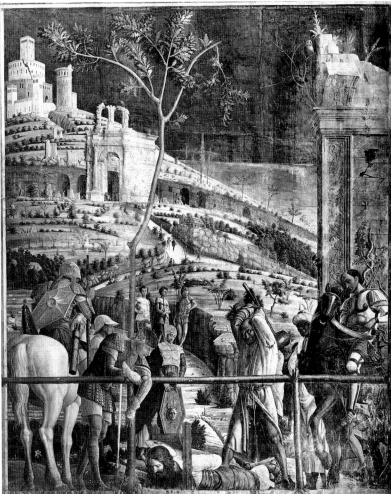

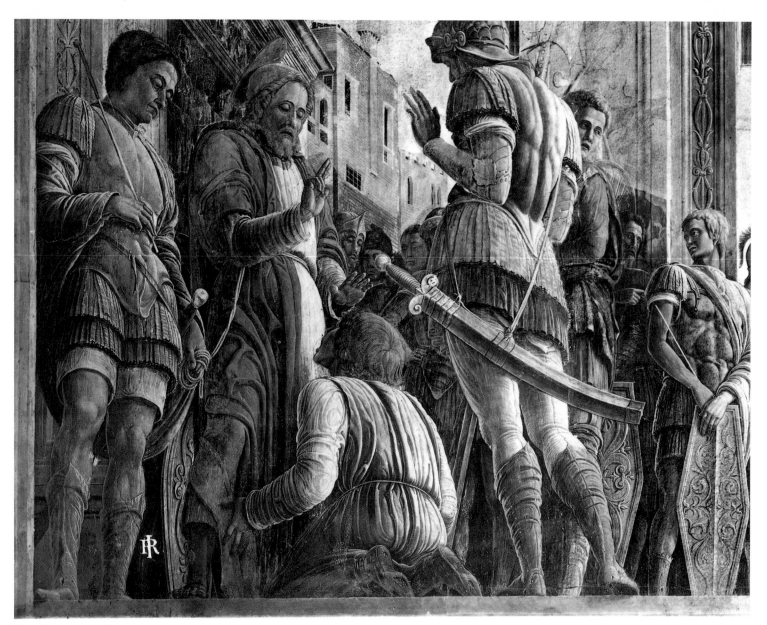

Detail, *St. James Led to Execution*

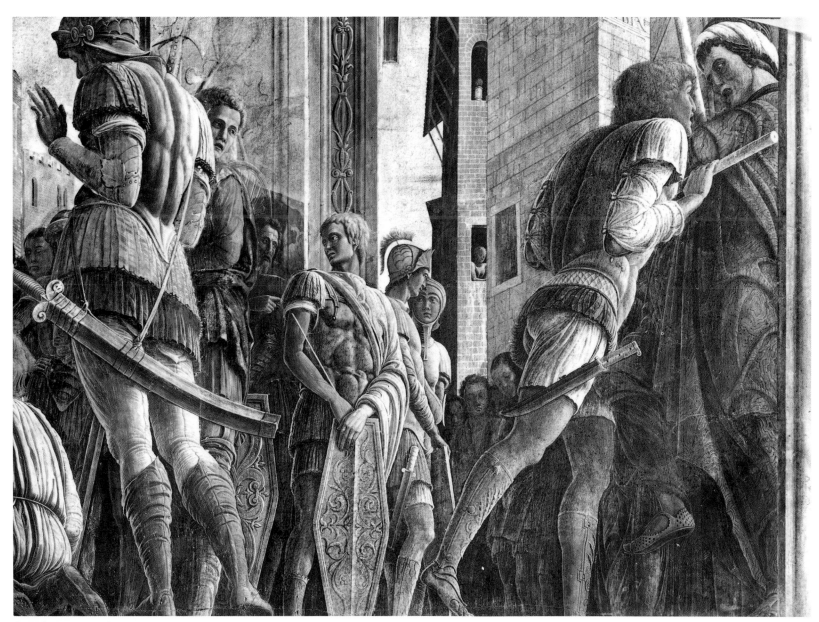

Detail, *St. James Led to Execution*

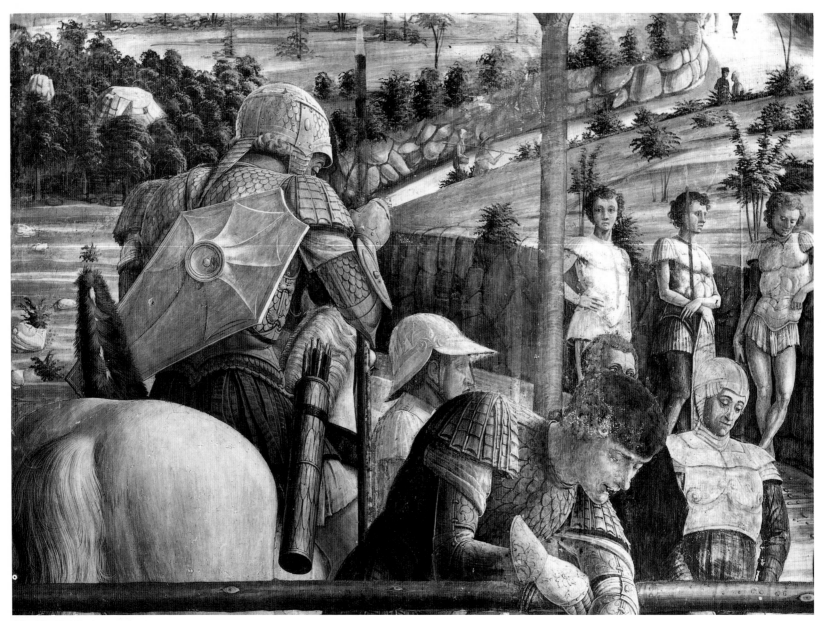

Detail, *The Execution of St. James*

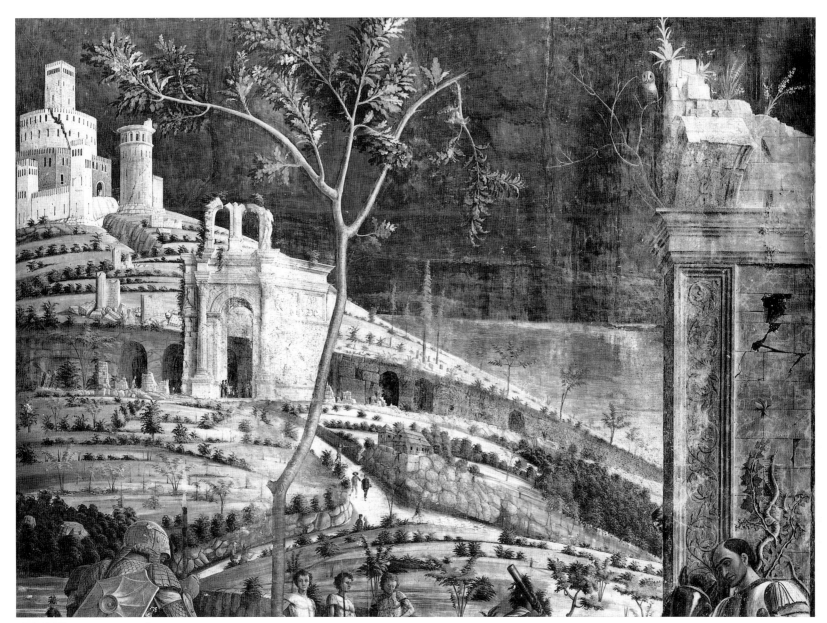

Detail, *The Execution of St. James*

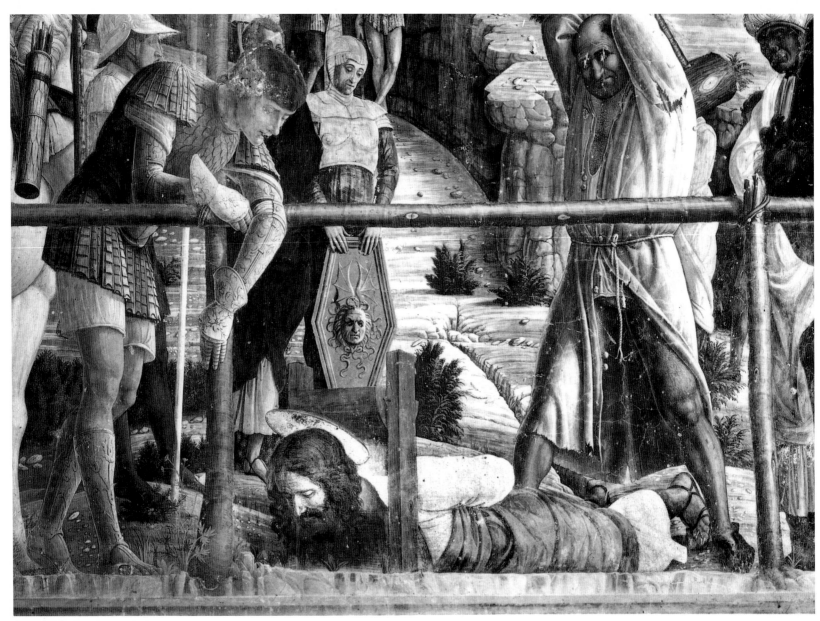

Detail, *The Execution of St. James*

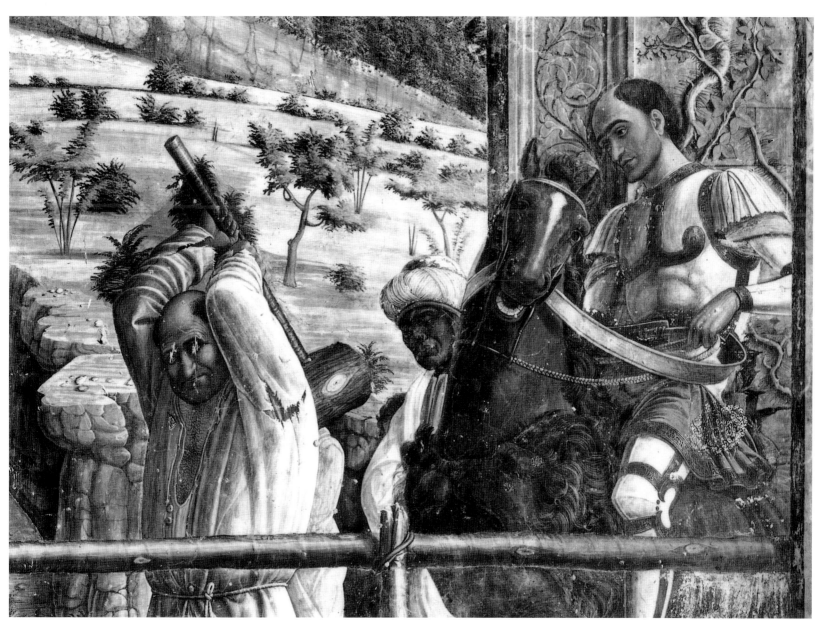

Detail, *The Execution of St. James*

St. Christopher Before the King of Canaan and St. Christopher Encounters the Devil

The attribution of these two scenes has been much debated, but the most probable candidate for the one on the left is the Marchigian painter Girolamo di Giovanni da Camerino, who joined the painter's guild in Padua in November 1450. This would accord with the probable date of the frescoes. The one on the right is usually ascribed to Ansuino da Forlì, who signed the fresco immediately below, but this is far from certain.

The scenes treat the medieval legend of St. Christopher, a giant—"twelve cubits [about twenty feet] in height," according to the *Golden Legend*—who conceived the ambition of serving only the most powerful king. In the left-hand scene he learns that his first master, the King of Canaan, was frightened by the name of the Devil. He thereupon set out to find Satan, whom, in the right-hand scene, he encounters in the desert in the guise of a fierce soldier leading his troops.

These are wonderfully genial narratives, imprinted with a fairy-tale quality. No attempt has been made to give the scenes an *all'antica* cast or to suggest any weight or gravity to the events. The costumes are of the fifteenth century, and the artist has not, in contrast to Mantegna, studied his figures from models. The approach to narration is straightforward, with few embellishments. On the left, the focus of the perspective is given over to a dwarf knocking at the door. This recalls a detail of a much admired fresco cycle in the church of Sant'Egidio in Florence by Domenico Veneziano (destroyed in the 17th century but known through descriptions) that showed the birth of the Virgin with a child beating on the door of the bedchamber with a hammer. It is known that Girolamo di Giovanni's compatriot Giovanni Boccati went to Florence prior to visiting Padua in 1448, and it is possible that Girolamo accompanied him. This would explain the strong Florentine character of the fresco: the foreshortened divisions of the ceiling seen through the arched opening of the king's palace recall the work of Filippo Lippi.

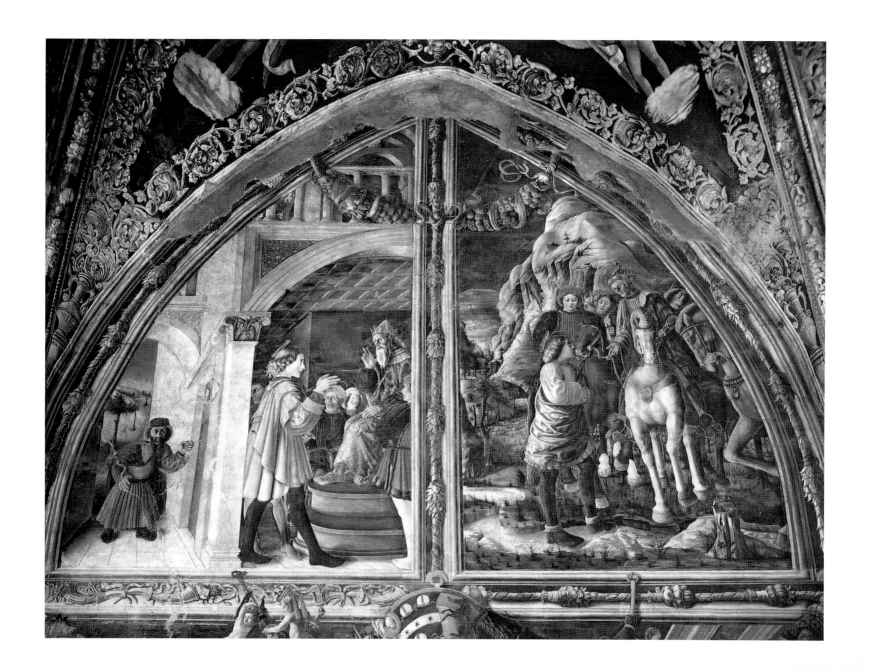

St. Christopher Carrying Christ Child and The Arrest of St. Christopher

Christopher discovered the Devil's own temerity when they encountered a cross and the Devil took flight. From that point on he vowed to serve only this unknown lord. A hermit encountered in the wilderness instructed him to offer Christ the service of carrying travelers across a dangerous river. One night Christopher answered the call of a child and, bearing him on his soldiers, set out, only to discover midway across the river that the tremendous weight of the child put him in peril. The child then revealed himself as Christ. The event inaugurated Christopher's career as a Christian, which culminated in his conversion of the soldiers sent by the King of Lycia to arrest him. These episodes are treated in companion scenes painted by different artists, Bono da Ferrara (on the left) and Ansuino da Forlì (on the right).

Bono da Ferrara was a pupil of Pisanello at the Este court in Ferrara, but to judge from his fresco of *St. Christopher Carrying the Christ Child*, the two determining influences on his work were the miniaturists employed by the Este and the luminous frescoes of Piero della Francesca, who worked for them in or around 1450. Piero's influence is especially evident in the compact, stylish figure of the saint and the reflective surface of the placid river. However, Bono's work shows none of Piero's mastery of perspective: his buildings and the ruins read as insertions, unrelated to each other and to the hilly landscape. Bono's miniaturist tendencies are largely confined to the borders of the fresco and the garlands, supported by dragon heads similar to those that formed the initials on the choir books of the Cathedral of Ferrara. In the background, near the church where the hermit instructs the giant on his charitable task, the two deer recall the work of Pisanello. Bono evidently painted the fresco in the summer of 1451. He did so clandestinely, without joining the painters' guild, and afterwards he was forced to desist working in Padua.

In contrast to Bono, Ansuino da Forlì had strong local connections. He had worked with Pizzolo in a chapel in the Palazzo del Podestà in Padua decorated in part by Filippo Lippi in the mid-1430s. The Ovetari fresco was, however, his only secure work. Payments for it were made in October 1451, after the departure of Bono. As one might expect from his Paduan connections, in this ambitious fresco he attempted an *all'antica* setting, replete with a double-arch portal at the back with views onto a pastoral landscape. His figures are compactly massed, and in the two quarreling youths beneath the colonnade we recognize his study of Donatello's bronze reliefs for the altarpiece of the Santo in Padua on which the Florentine was then working. Ansuino clearly intended his setting to reflect that of Mantegna for *St. James Baptizing Hermogenes*, and a comparison of the two works suggests both Ansuino's gifts as a narrator and his limitations as an architectural designer. Perhaps the most puzzling and fascinating detail is the profile portrait he inserted among the bystanders.

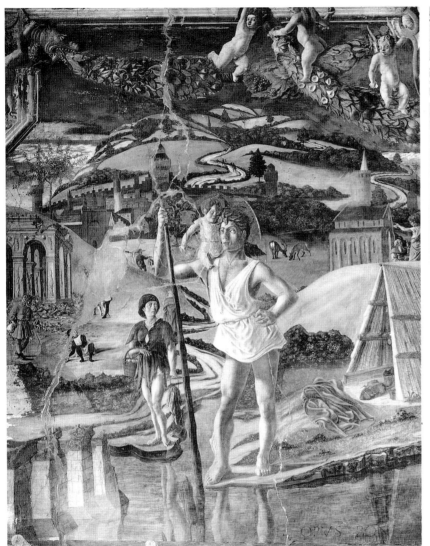
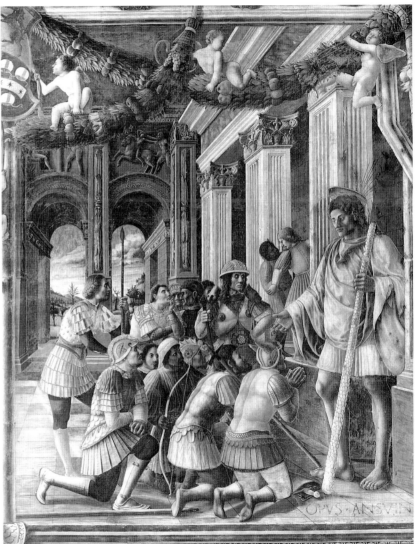

The Attempted Martyrdom of St. Christopher and St. Christopher Beheaded

Possibly the last scene painted by Mantegna in the Ovetari Chapel—dating as late as 1457—is this unified composition showing, at the left, *The Attempted Martyrdom of St. Christopher*, and, at the right, his decapitation. The fresco survives but is in ruinous condition: the left and center areas are completely illegible, and the outer illusionistic border that enhanced the impact of the scene is lost. (The original effect is best appreciated from copies: see fig. 8.) Originally, the border functioned less as a window than as a proscenium for the action, which seemed to spill into the chapel.

According to legend, Christopher suffered many torments at the hand of King Dagnus, who had the saint tied to a pillar and ordered his soldiers to shoot him with arrows. The arrows remained suspended in the air; one even reversed its course and struck the king in the eye (this is shown in the left-hand window of the palace). Christopher thereupon instructed that after his martyrdom the king should make a poultice of his blood and apply it to his eye, which would be healed. The saint was beheaded and the king, upon being healed, converted; he is, in fact, shown looking at the saint's foreshortened body from the right-hand window. The saint's head was positioned at the edge of the picture plane.

Breaking with the simple, fairy-tale approach of his predecessors, Mantegna has lavished on this panoramic scene the skill of a master filmmaker intent on capturing the bewildering tumult with a wide-angle lense. The setting is an imaginary city of unparalleled vivacity and complexity. The eye can wander at ease through the giant arched bridge or aqueduct up stairs to another square flanked by buildings of a distinctly Venetian character. By contrast, the king's splendid palace seems to have been constructed of ancient fragments. It is surrounded and even penetrated by an imaginative grape arbor, the trelliswork of which accentuates the pictorial depth. (The grapes and the fig tree may carry allusions to the Resurrection.) The atmospheric blue sky (the red on the left is the preparation for azurite blue, which has flaked away) bathed the brick and stucco buildings in a soft light.

The fresco includes portraits of a number of Mantegna's humanist friends and a mocking likeness of his teacher, Squarcione, who is shown as the short fat man holding a halbert and looking up to the giant saint at the left. Mantegna had taken Squarcione to court to win his independence as an artist, and he clearly relished this occasion to deride his former master, who is reported to have criticized the sculptural appearance of Mantegna's figures.

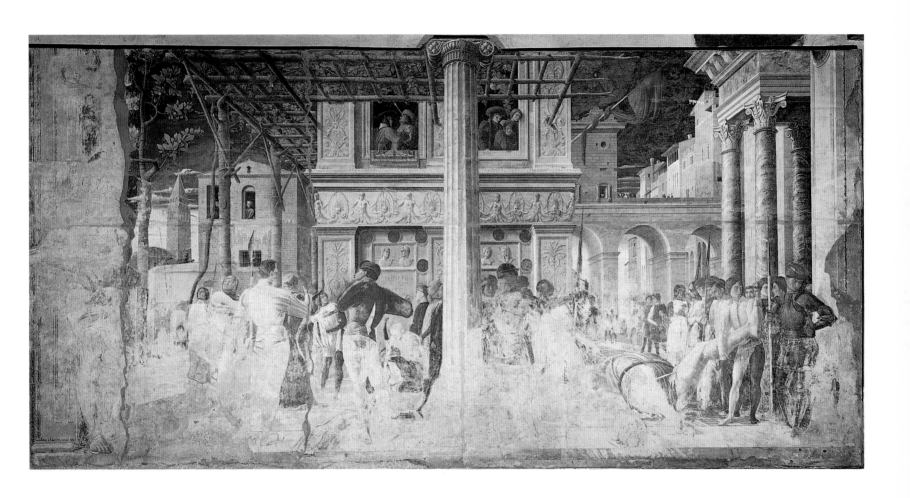

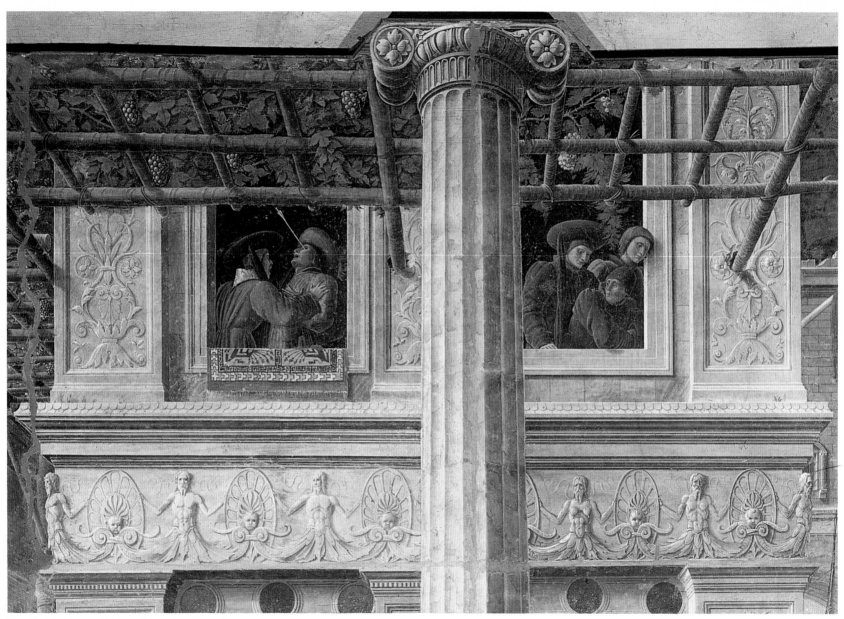

Detail, *The Attempted Martyrdom of St. Christopher*

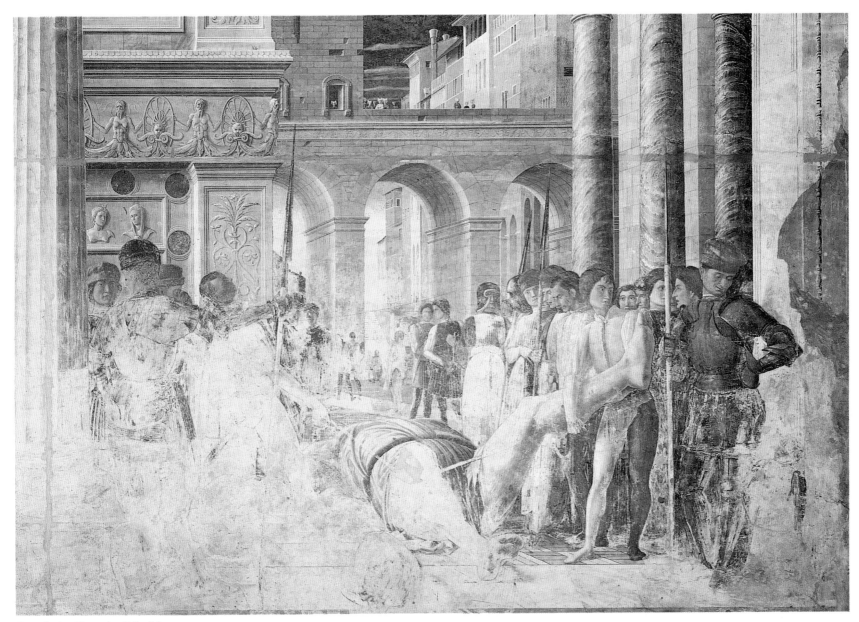

Detail, *St. Christopher Beheaded*

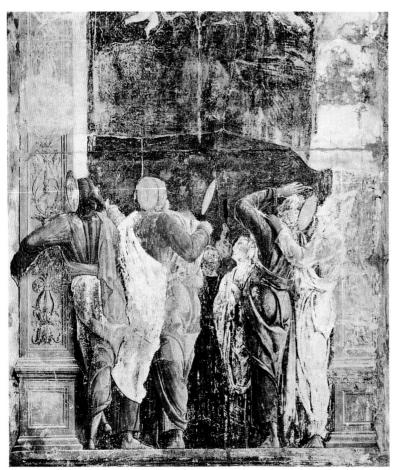

Detail, *The Apostles*

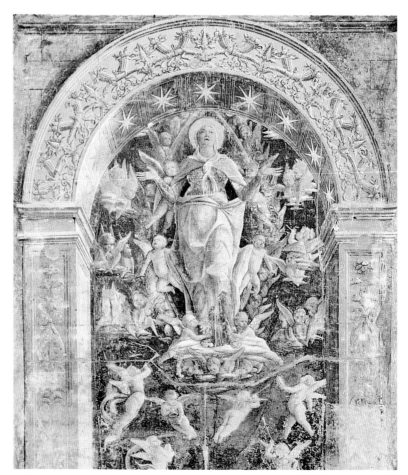

Detail, *The Virgin*

Assumption of the Virgin

In early February 1457 the widow of Antonio Ovetari, Imperatrice Forzate, sued Mantegna for breach of contract, noting that he had depicted only eight of the twelve disciples in the *Assumption of the Virgin* on the end wall—an area that had originally been assigned to Pizzolo, who died before he could carry it out. Not only does the document establish the approximate date of the fresco—which fortunately survives, albeit in a much damaged state—but it sheds light on the revolutionary character of Mantegna's approach and how little it was understood by someone brought up with expectations formed by tradition. The scene is viewed as a real event happening before the spectator's eyes. The Virgin sails heavenward behind the arch opening, observed by apostles below. The men seem to spill out into the actual space of the chapel. They are viewed from below, and it is this illusion of extension both in front of and behind the arched opening that allowed Mantegna to edit the number of apostles: the twelve are present *by implication*.

The scene is unrelated to the stories of Sts. James and Christopher, but it does have a direct bearing on the terra cotta altarpiece, which shows the Madonna and Child accompanied by saints. From the entrance of the chapel only the Virgin could be seen above the altar, making the connection apparent. It is when the visitor moves behind the altar and looks up at the fresco from an exaggerated angle that the saints come into view. This explains their elongated bodies, created to compensate for the close, low viewing point. The fresco serves as a sort of manifesto of Mantegna's idea of art as an extension of visual experience.

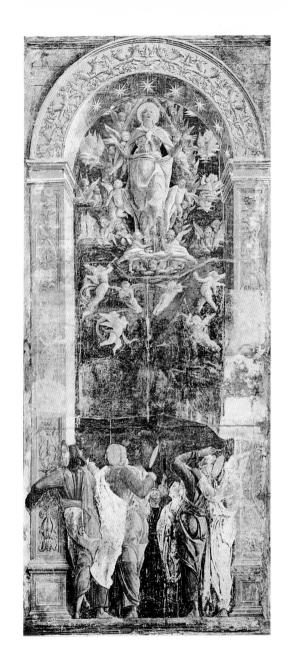

Opposite: The Palazzo Ducale, Mantua

Part II: The *Camera Picta*, Mantua

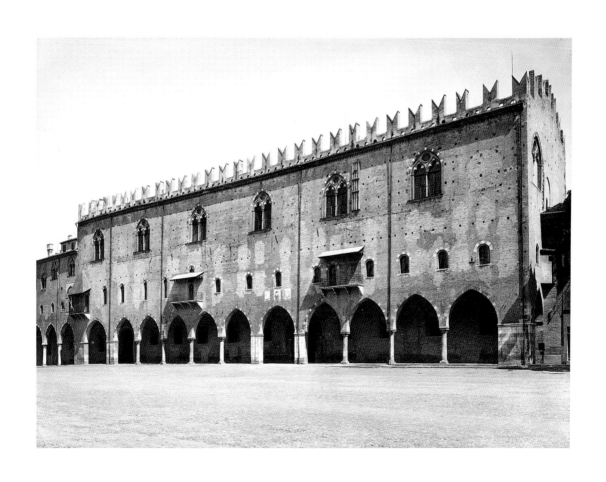

General Views of the *Camera Picta*

The *Camera Picta*, or painted room, is in a tower of the four-teenth-century Castello di San Giorgio in Mantua. In the 1450s Ludovico Gonzaga began remodeling the castle for his residence. Mantegna worked in the room from April 1465 until the summer of 1474. Following court conventions, the *camera* was used both as a bedroom and as an audience chamber. It has two doors and two windows, one of which commands a view over the lake that all but surrounds Mantua. The architect in charge of revamping the room must have been Luca Fancelli, a Florentine who had been recom-mended to Ludovico by Cosimo de'Medici and was in charge of architectural projects in Mantua from 1450. He was responsible for the design of the corbels, the fireplace, and the door moldings—all of a distinguished Renaissance character (Fancelli also carried out plans for two churches designed by Leon Battista Alberti).

As in the Ovetari Chapel, Mantegna used the actual architecture of the room as his point of departure for an elaborate, fictive archi-tecture of exceptional elegance and richness. This consists of a dado inset with simulated marble incorporating the Gonzaga livery colors of pink and green on which are piers with simulated carvings against a gold background (the design for these derives again from one of the Roman monuments in Verona). The fictive piers support a vault dec-orated with images of sculpted putti, busts of the first eight Roman emperors, and spandrels illustrating episodes from the lives of Hercules, Orpheus, and Arion—doubtless symbolic of the military and cultural ambitions of Ludovico—all shown against a simulated gold mosaic background. Garlands and medallions with Gonzaga heraldic devices seem suspended between the piers and richly textured curtains appear hung from rods stretched between the corbels. On the south and east walls the curtains fill the openings, while on the north and west walls they have been pulled back to reveal the Gonzaga family against, respectively, a private garden enclosure and a fantastical land-scape. The open pavilion is not dissimilar in character to the setting of the Virgin and Child in Mantegna's *San Zeno Altarpiece*, except that here the viewer is on the inside looking out rather than on the outside looking in. Mantegna is clearly referring to the reports in Vitruvius and Pliny of the decoration of ancient villas with columns and land-scape views. The illusion works most powerfully from the center of the room, and it is from this point, looking straight up, that Mantegna painted his greatest tour de force of illusionism: the cele-brated *oculus* with a balcony that supports a potted citrus as well as figures who gaze down in amusement on the viewer below.

Light was crucial to the illusion, and Mantegna carefully differenti-ated between the actual light coming through the two windows, which illuminates the ceiling reliefs, the piers, and the figures standing on the dado, and an outdoor light that bathes the distant landscape and the figures looking through the *oculus*. In this way, the figures on the dado are made an extension of the viewer's world inside the pavilion while the "great beyond" is suggested in the landscape and the *oculus*.

Mantegna began work on the ceiling, proceeded to the fireplace wall, and then worked clockwise, finishing with the wall showing a distant landscape. It is frequently forgotten that the simulated drap-ery must have taken an enormous amount of time and labor, what with the use of gold and the elaborate patterns, now lost. The fire-place wall is largely *a secco*, with the use of oil, as are the curtains, while the west wall was carried out in a more conventional tech-nique combining fresco with *a secco* finishing details.

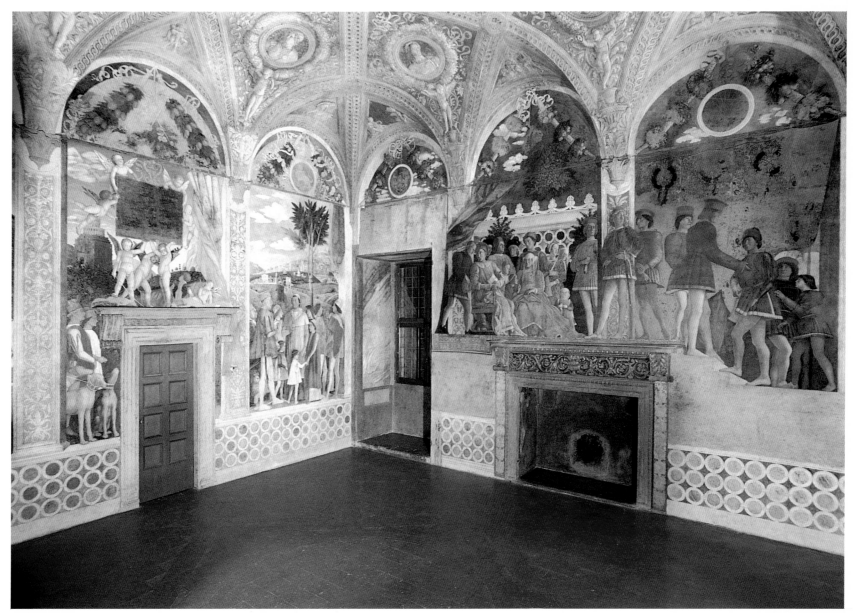

Northwest corner

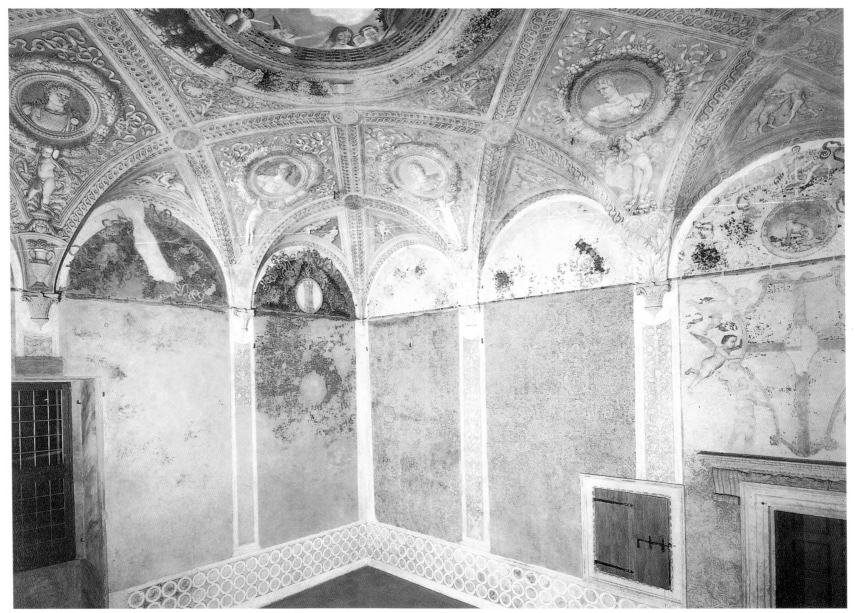

Southeast corner

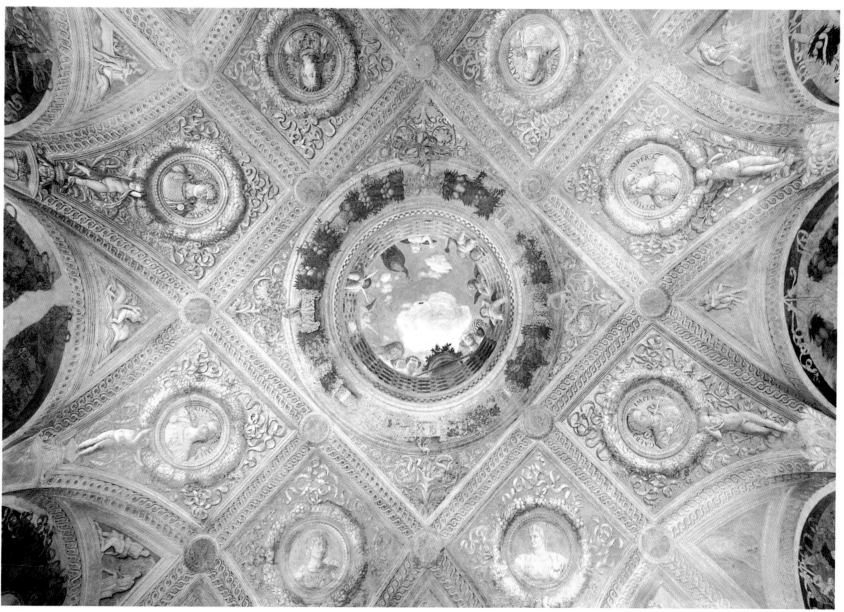

Ceiling

North Wall: Ludovico Gonzaga and His Court

The principal scene showing Ludovico Gonzaga and his wife, Barbara of Brandenberg, with their family and court seated within a walled garden is on the fireplace wall. Mantegna gave the family an air of informality, enhanced by the conversation between Ludovico and a courier or servant, evidently about the contents of the letter the marquis holds. The marchioness looks on intently, while other court figures prepare to receive a visitor, shown entering from behind a raised curtain, beyond which is visible a landscape with laborers (the floral-patterned curtain is damaged to the point that its form is no longer legible behind the figures, compromising the effect of richness and an essential aspect of the illusionist scheme). The gloves held by some of the figures are symbols of their standing. Numerous attempts have been made to identify the incident depicted, but there is no reason to believe that Mantegna had been required to commemorate a specific moment in Ludovico's rule—even one so important to him as the elevation of his son Francesco to the cardinalate in 1462 (at the time, the seventeen-year-old Francesco was studying in Pavia). What Mantegna has achieved here is the first great conversation portrait in European art, and it is the narrative character of the scene—by which he gave vivacity to the family and made them living rather than passive presences—that has led (or misled) scholars into seeking a hidden meaning or specific historical incident. Mantegna's compelling image of a benign, approachable court favorably influenced all subsequent histories of the Gonzaga family.

To enhance the illusion of real presences—which must have been extraordinary when the murals were in good condition—Mantegna showed his figures standing or sitting on a platform above the actual fireplace mantle. This platform projects illusionistically in front of the piers (note how the curtain at left is wrapped around the pier behind the courier). The marquis's special status is alluded to by the carpet under his stool, while another carpet is used for the other figures. The stairs have been foreshortened empirically to a secondary vanishing point since their form would not otherwise have been comprehensible.

We can be fairly certain of the identities of a number of the figures. To Ludovico's left is his third son, Gianfrancesco, who places his hands affectionately on his youngest brother, Ludovico, already at age nine possessor of an ecclesiastical office (papal protonotary). A daughter, Paola, holding an apple, leans on her mother's lap, while Barbara's fourth son, Ridolfo, stands behind his mother. To his left is another Gonzaga daughter, Barbara, attended by one of the famous court dwarfs. The figure in black to Ridolfo's right is likely a tutor—but not Ludovico's tutor, Vittorino da Feltre, who had died in 1446—or a resident humanist. The dog beneath Ludovico's chair has been identified as his favorite pet, Rubino (Red), who died in 1467 and was buried near the castle.

The scene was carried out largely *a secco*, and this accounts for the poor condition. Especially lamentable is the loss of many of the glazes, so that many of the transitions from lit to shadowed portions now read too abruptly.

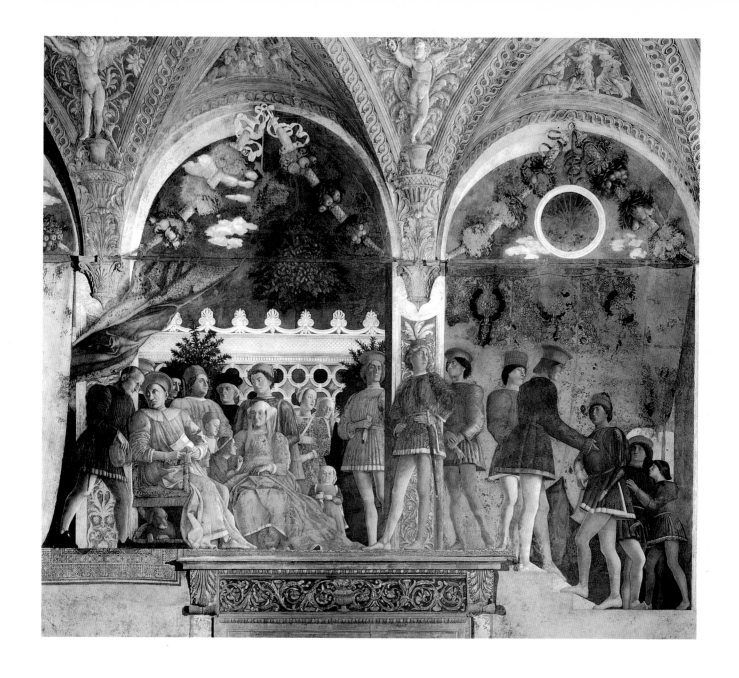

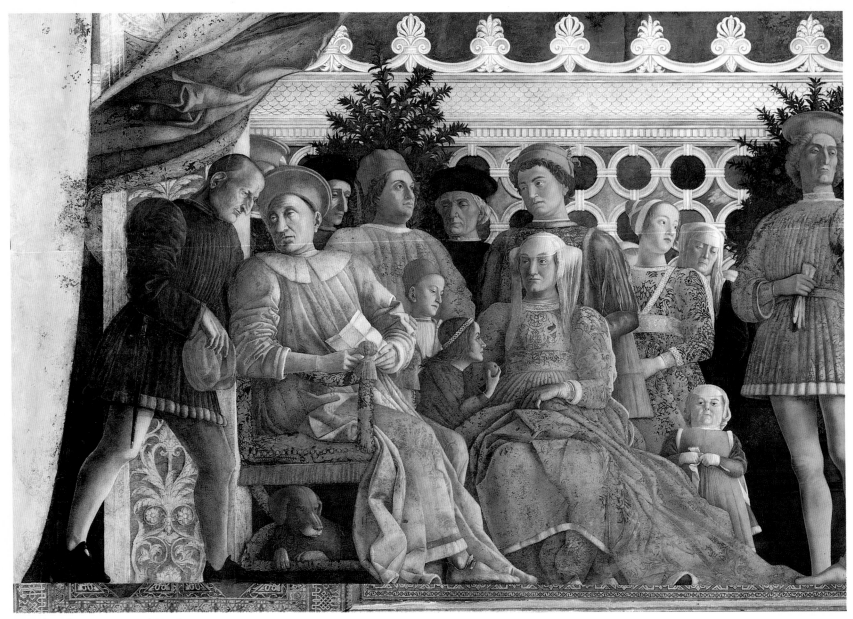

Detail, *Ludovico Gonzaga and His Court*

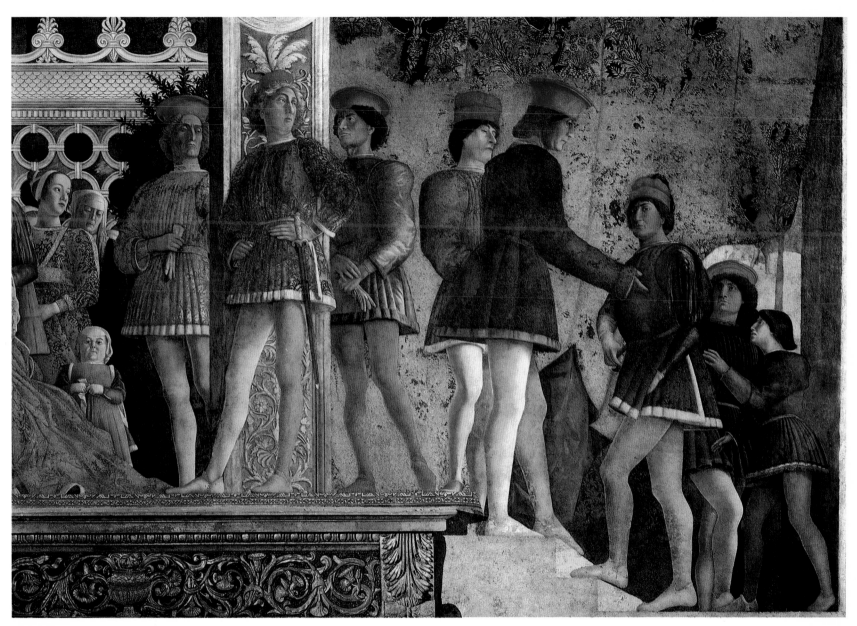

Detail, *Ludovico Gonzaga and His Court*

West Wall: Grooms; Dedicatory Tablet; Gonzaga Family with Relatives

The west wall, painted largely in *buon fresco* but with embellishments made *a secco*, is divided into three distinct scenes, since the figures stand on the dado behind the piers rather than on a platform in front of them. At the left are grooms with one of Ludovico's horses (the Gonzaga had a famous stud farm). In the center figures wearing Gonzaga livery hold dogs, while above the doorway putti position the dedicatory tablet, shown as though suspended from an iron rod. On the right, in the final division of the west wall, the chief male members of the Gonzaga family are brought together with their retainers and most highborn relatives in a carefully articulated relationship, one that in its formal traits recalls Roman Aurelian reliefs. (Had Mantegna visited Rome following his documented trip to Florence in 1466?) The division is obviously expressive of a social hierarchy, and this seems also to characterize the continuous landscape view, which shows fortresses on the left, a mausoleum in the center, and a fictionalized Mantua on the right.

Elaborate attempts have been made to relate the right hand scene to the meeting between Ludovico and his son Francesco at Bozzolo following the announcement of the elevation of the latter to the cardinalate in December 1461, but this is supported neither by the ages of the figures (Francesco was then only seventeen years old) nor by some of the children included, who were not yet born. There can, indeed, be little doubt that the fresco was executed in or shortly before 1474, and we know that in 1472 Francesco paid a visit to his father in Mantua together with the great humanist Leon Battista Alberti and the poet Poliziano (who wrote his *Orfeo* for the Gonzaga court). Francesco must have sat for Mantegna at that time (the artist is known to have entertained the cardinal in his own home). The subject of the fresco is the glory and continuation of the Gonzaga lineage, not some incident from their lives, and it is for this reason that the background includes a marvelously fictionalized Mantua, identifiable by the Gonzaga coat of arms on the portal behind the small pyramid and a crenellated tower outside the city (see also p. 91). Outside the walls of the city is a temple or villa-like building with, in its tympanum, a scuptural decoration that has the appearance of showing Orpheus charming the animals. Nearby is a statue of Hercules, again underscoring the complementary traits of the Gonzaga family, who made their living as hired captains.

It is not known what the recess at the far left was used for, but it is original and must have had a door that, when closed, was painted so as to be integrated with the fresco decoration.

The garlands in the lunettes are composed of ears of grain, varieties of grapes, pine cones, and varieties of squash, carried out with the precision of a botanist. The heraldic devices on the two suspended discs show a winged ring decoy employed in a falconry and hydra (the latter is largely a modern reconstruction). The interlace patterns of the cutains, painted *a secco*, have mostly disappeared.

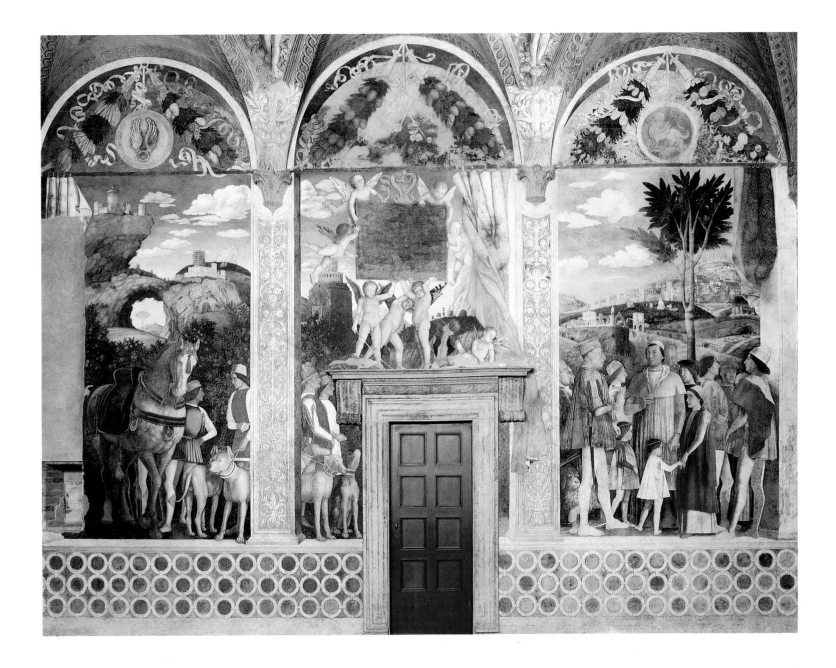

Grooms

Though the blues have lost much of their glazes and a large, rectangular area has been destroyed, this portion of the decoration is in relatively good condition and gives some idea of Mantegna's response to landscape painting. He preferred the fantastical over the ordinary—especially given the flat, characterless nature of the countryside surrounding Mantua. Yet, if the rock formations are wildly implausible, the buildings are conceived with an eye to architectural practice.

At the top of one mountain is a crenellated castle with a ruined tower: grander, perhaps, than those dotting the Lombard plain, but reflecting Gonzaga castles built under the direction of their Florentine architect Luca Fancelli. Nearby, the keep of another fortress is under construction with an elaborate scaffolding, and men at work. Mantegna has carefully distinguished between the various kinds of building materials then in use. His fascination with caves is well in evidence in the detail below this second fortress; in the corresponding scene at the far right the caves seem to be excavation sites or quarries, suggesting Mantegna's interest in archaeological digs (see p. 90). We know of archaeological excursions undertaken by Mantegna with humanist friends, but not of any excavations. Nonetheless, excavations were a natural complement to humanist/archaeological studies: in 1466 the minor humanist Antonio Ivano da Sarzano reported on the discovery of Etruscan tombs in a cave near Volterra.

Typical of Mantegna's subtle imagination is the corner of the curtain that has come untied and falls back to reveal the castle.

84

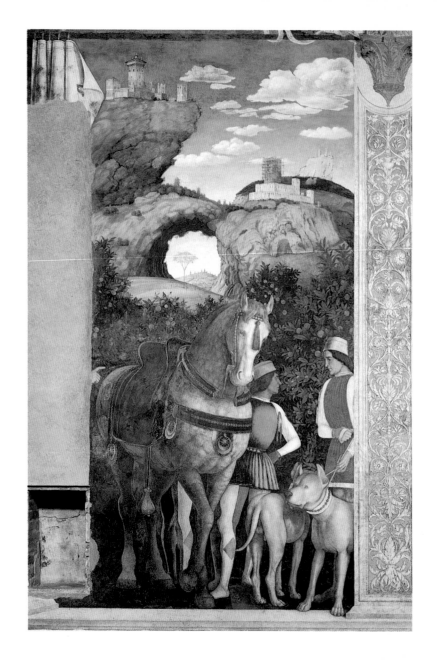

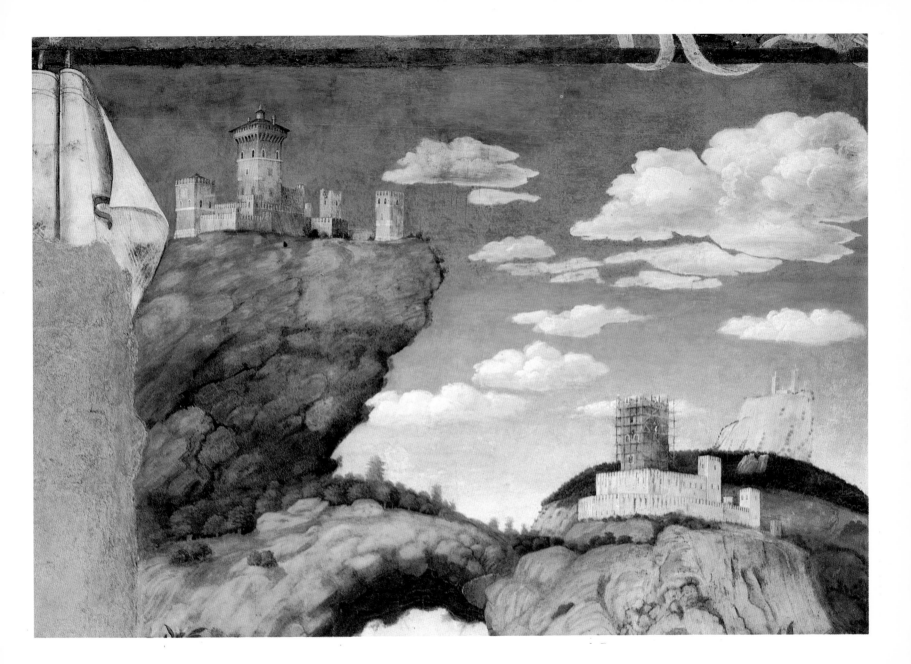

Putti with Dedicatory Tablet

The manner in which the putti are made to stand on the door molding, on which the drapery is shown as though resting, is indicative of Mantegna's attention to detail. They have butterfly wings rather than the feathers of their companions in the *oculus*. The reason for this distinction is not clear. Mantegna obviously relished the occasion of introducing a lighthearted note by showing their struggle to position the heavy tablet inscribed in Latin with the following dedication:

"For the illustrious Ludovico, second Marquis of Mantua, best of princes and most unvanquished in faith, and for his illustrious wife, Barbara, incomparable glory of womankind, his Andrea Mantegna of Padua completed this slight work in the year 1474." The reference to "slight work" (opus hoc tenue) is clearly tongue-in-cheek and is nicely parodied by the apparent weight of the tablet. Indeed, immediately to the right of this scene, hidden in the foliate decoration of the pier, Mantegna has included his self-portrait, gazing at the dedicatory tablet. As so often the case with Mantegna, he was inspired by a classical prototype: pilasters on the Arco dei Gavi in Verona.

The building in the background must be Mantegna's idea of a classical mausoleum, though if so it departs from the descriptions given by both Vitruvius and Alberti. Its juxtaposition with the dedicatory tablet suggests that a primary function of the *camera* was to eternalize the fame of the Gonzaga family.

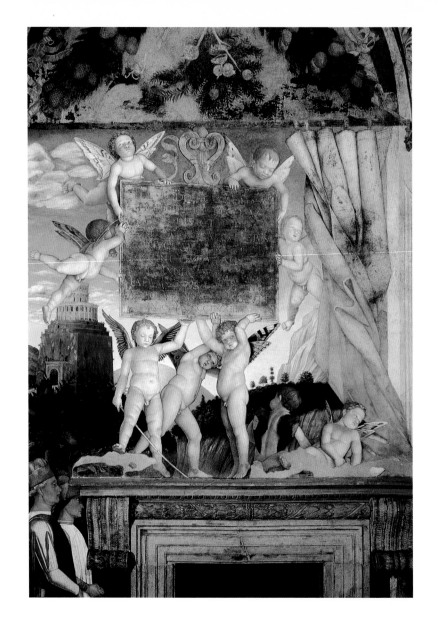

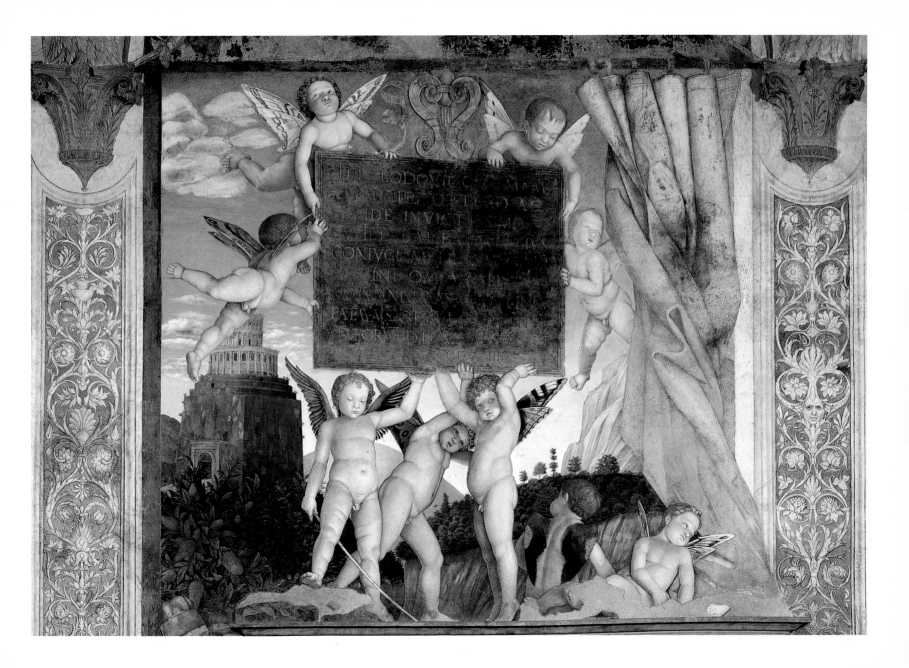

Gonzaga Family with Relatives

To the left is Ludovico. Facing him, on the opposite side, is his heir, Federico, and next to Ludovico is Federico's son and future heir, Francesco. All are in strict profile, the preferred formula for court portraits. Between them, in three-quarter view, is Cardinal Francesco, who holds the hand of his younger brother and fellow ecclesiastic, Ludovico, who in turn holds the hand of his nephew, Sigismondo, who was also destined for a career in the church. Thus, two complementary groups—one secular, the other clerical—have been created. Ludovico's suzerain, Emperor Frederick III, is either the figure in yellow or the man in three-quarter view with a reddish hat, while the marquis's kinsman, King Christian I of Denmark, is perhaps the figure in black.

The city in the background, decorated with Gonzaga coats of arms, must be considered one of the great, imaginary vistas in western art. From the ancient ruins that litter the landscape or stand in solemn abandon within the city walls to the classical-styled buildings that confer on it a renewed Roman dignity; from the mammoth fortress that dominates its silhouettes to the simple domestic structures with their picturesque conical chimneys that line the main street; from the outer wall—incorporating ancient as well as modern brickwork—to the gate patterned on a triumphal arch; from the Roman arena—based on that at Verona—to the towers and domes of Christian churches; from the criminal shown dangling from a gibbet outside the walls to the laundry drying on poles projecting from the pink tower, this is an image of civic life at once Romantically evocative and compellingly real. It is also a testament to Mantegna's architectural as well as archaeological interests.

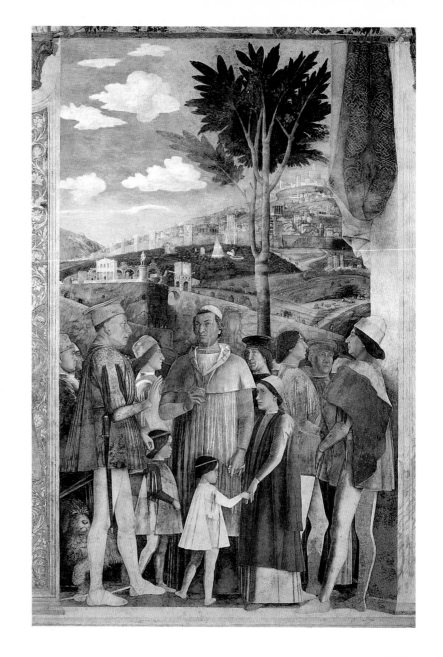

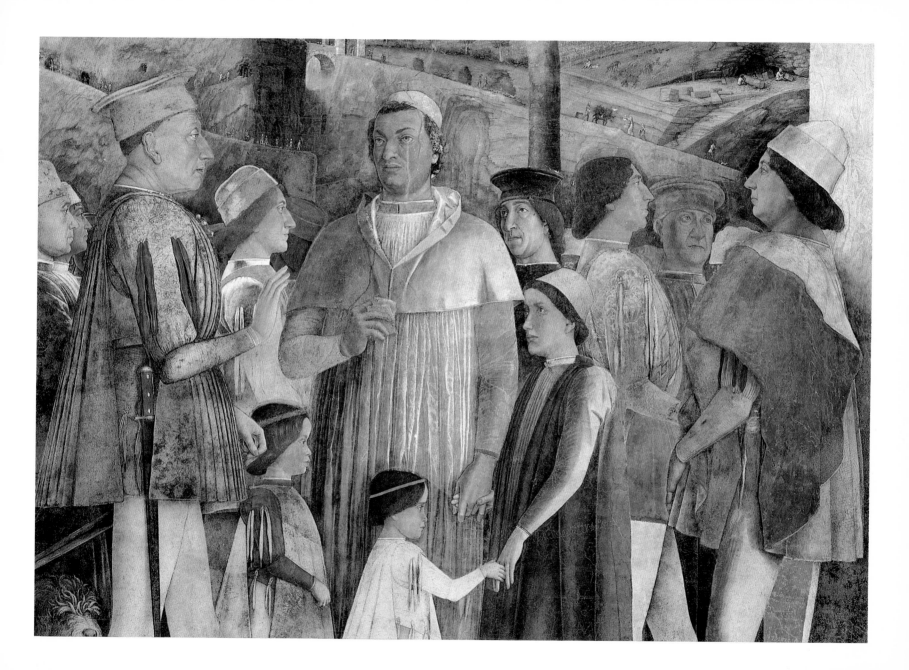

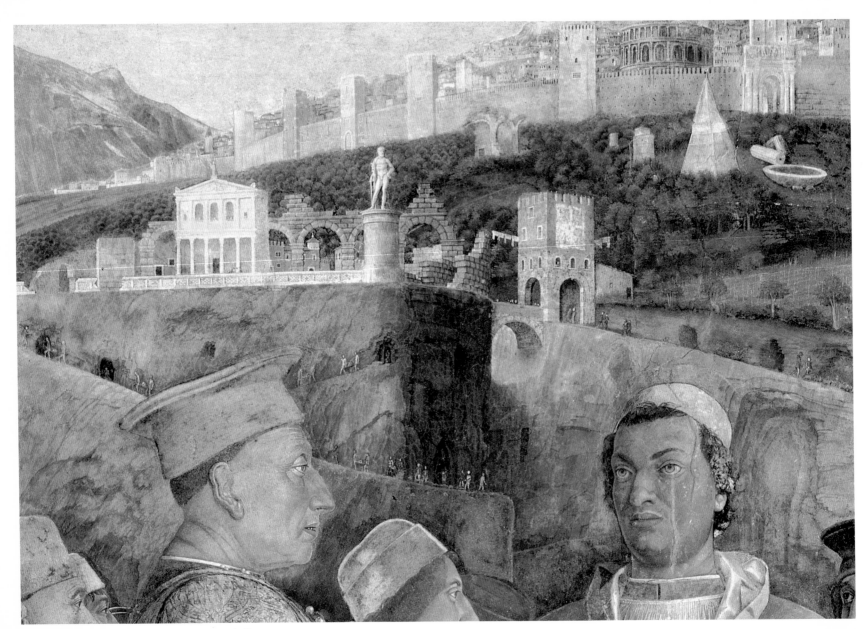

Detail, *Gonzaga Family with Relatives* (upper left)

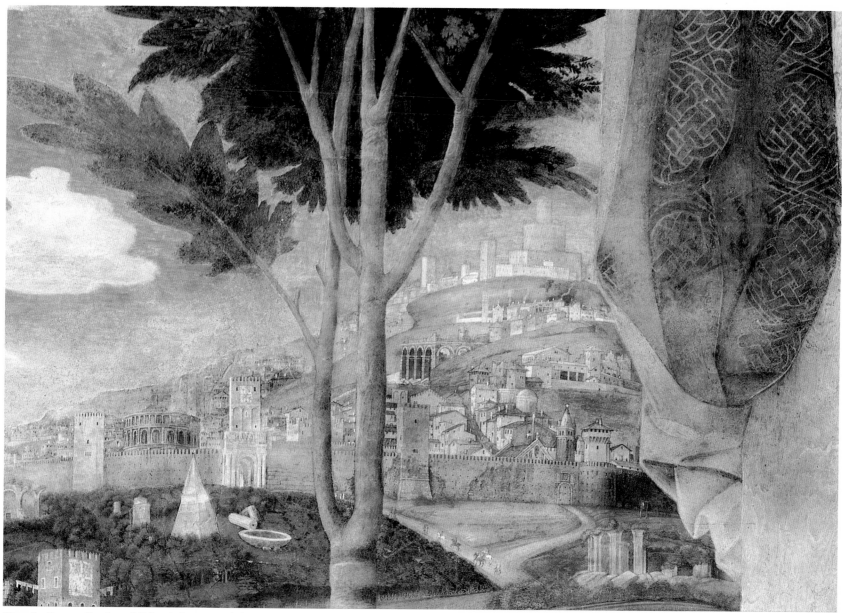

Detail, *Gonzaga Family with Relatives* (upper right)

Ceiling with *Oculus*

No part of the *Camera Picta* is more famous and was to have a greater critical fortune than the trompe l'oeil *oculus*. Much has been written to pinpoint Mantegna's inspiration and find a possible literary key to its meaning. As suggested earlier, the likelihood is that the *oculus* was primarily a tour de force of illusionism, inserted both as an artistic statement and as a witty interpolation into the room itself. It is the one scene in which the action is completed by the viewer rather than by someone figured in the fresco. One of the putti threatens the viewer with an apple held out over the open space, while a well-dressed woman playfully fingers the pole on which a tub of citrus is precariously balanced. The other women enjoy the prospect of the unsuspecting viewer being surprised, and it is for the viewer's benefit that this scene is clearly intended. One of the putti seems to have gotten his head stuck in the balustrade; another is indicated only by his hand holding a stick or, more playfully, a peashooter. Capping off this lighthearted scene is a magnificent peacock, a bird of notable beauty but with a terrible temper and an abominable call. Peacocks were prized at Italian courts for their plumage: Pisanello drew them, and in 1469 Mantegna was asked by the marquis to draw two "galine de India," which may be peacocks. At one spot the clouds have taken on the momentary form of a face, in conformity with remarks made by a number of ancient authors, including Lucretius and Philostratus (the profile appears to the left of center in this reproduction). The pun is on nature as an artist versus Mantegna's own achievement. In a dialogue in the *Apollonius of Tyana*, Philostratus had compared the imagination required to perceive images made by chance in nature to the manual and mental facility necessary for the reproduction of an object in a painting, and Cicero, in the *De divinatione*, insisted that there was a world of difference between random images and the perfect image of a truly great artist. These were issues that were to be developed by Leonardo da Vinci in his notebooks, but they remind us that the seemingly insignificant detail of the face in the cloud, no less than Mantegna's audacious opening of a hole in a solid ceiling, was aimed at eliciting praise from an audience well-versed in their classical authors and increasingly open to the notion of artistic genius.

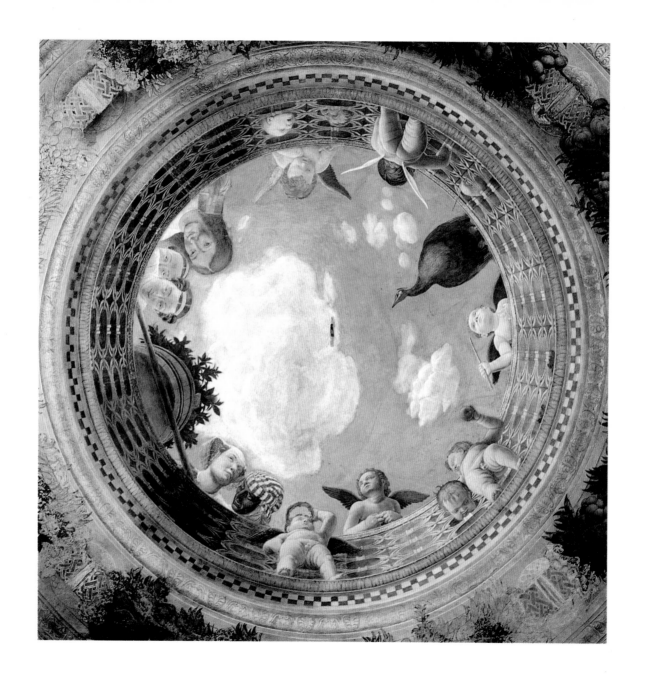

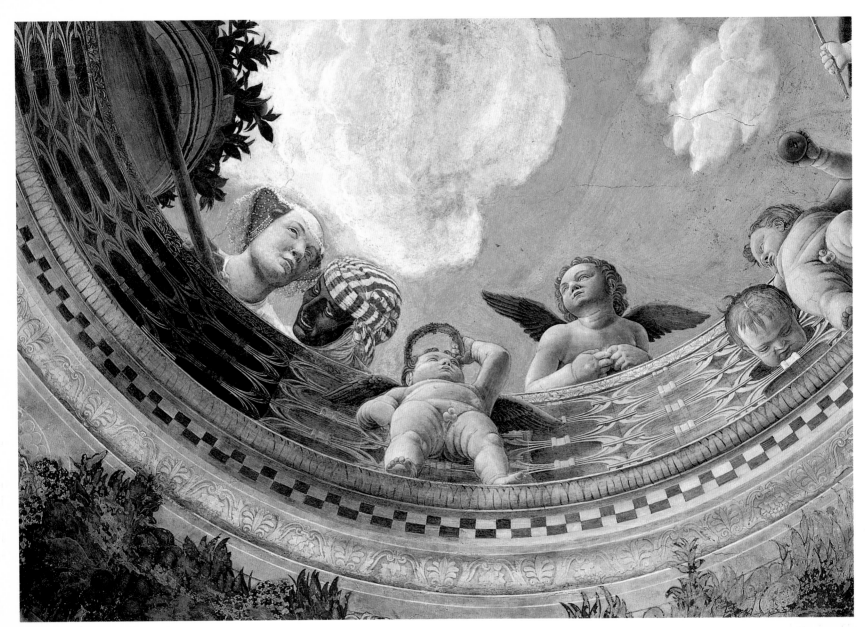

Detail, *Oculus*

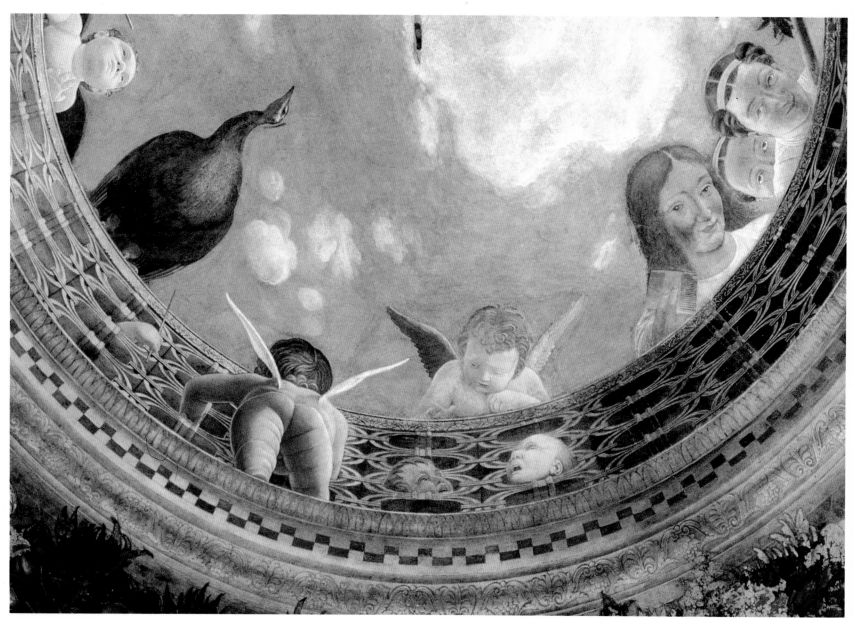

Detail, *Oculus*

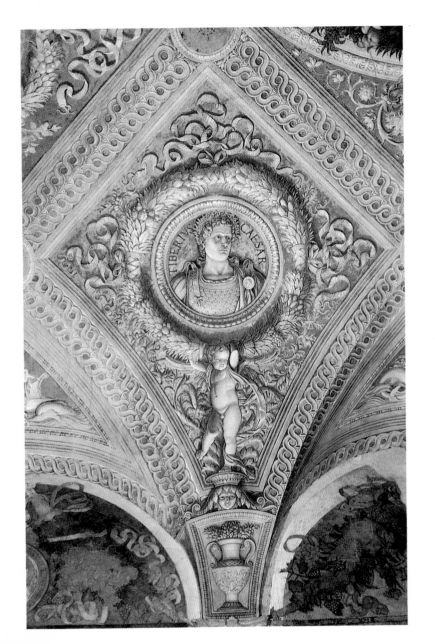

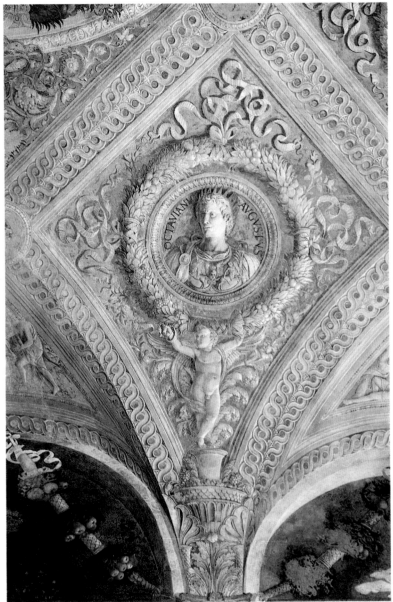

Busts of the Caesars

Busts of the Caesars were among the preferred images commissioned by rulers in fourteenth- and fifteenth-century Italy, particularly those who liked to trace their lineage to antique Roman families (the Scaligieri in Verona had a loggia of their palace decorated with busts painted by Altichiero in the late fourteenth century, and Lionello d'Este had a coin collection with the Caesars' likenesses). The vogue was certainly not hindered by the popularity of Suetonius' biographies of the first twelve emperors. No one before Mantegna, however, had conceived such archaeologically convincing depictions.

Mantegna's precise sources are not known, but in addition to Roman coins he would have known actual busts. (He later owned a marble bust of the empress Faustina that he sold to Isabella d'Este shortly before his death.) What gave life to Mantegna's scheme was his depiction of marble putti in lively poses supporting the surrounding carved garlands—a counterpart to the "living" putti who position the dedicatory tablet on the west wall. Here was a play on art imitating art and the various levels of reality possible in painting that was to be echoed a century and a half later by Annibale Carracci in his frescoes on the vault of the Palazzo Farnese in Rome, where we find feigned sculptural figures juxtaposed with seemingly "real" ones, and framed pictures contrasted to vistas of the sky. In the Scrovegni Chapel in Padua, Giotto had created, at the apsidal end of the building, vistas into two fictive chapels, and about 1425 Masaccio had created a trompe l'oeil space for his fresco of the Trinity in Santa Maria Novella.

However, no one before Mantegna had atttempted to transform the viewer's experience of an entire room by a sustained illusion of space and architecture. The *Camera Picta* was, indeed, the most complete formulation of art and its representational possibilities before Michelangelo's Sistine Ceiling, and its legacy can hardly be exaggerated.

Bibliography

The bibliography on Mantegna is enormous (see the 1992 Mantegna catalogue cited below). However, early-twentieth-century taste, as represented in America by Bernard Berenson and in Italy by Roberto Longhi, was strongly biased against Mantegna's intellectual bent and archeological interests, and this has deprived him of a really sympathetic critical framework, such as has formed our appreciation of the work of Piero della Francesca. (Longhi went so far as to deny Mantegna's historical place in the creation of a northern Italian Renaissance style, reversing his relationship with his brother-in-law Giovanni Bellini!) As a consequence, articles frequently present Mantegna as a dry, academic artist, and with the exception of Romano's essay, no study has accorded him his role as the first great humanist painter and the originater of a tradition that runs through Raphael, the Carracci, and Poussin down to David. The following bibliography presents only the most basic literature, with an emphasis on those works available in English.

General Works:

L. B. Alberti, *On Painting and on Sculpture*, ed. C. Grayson, London, 1972. (The basic treatise on which all Renaissance painting is to some extent indebted and without which Mantegna's art cannot be fully understood; originally published in 1435; the 1972 edition is the fundamental Latin-English text.)

D. Chambers and J. Martineau, eds., *Splendours of the Gonzaga*, London, 1981. (Catalog to an exhibition held at the Victoria and Albert Museum. The essay by C. Elam on Mantegna in Mantua is excellent, as are many other contributions; a good starting point for students interested in the Gonzaga.)

K. Christiansen, "Rapporti presunti, probabili, e (forse anche) attuali fra Alberti e Mantegna," *Leon Battista Alberti* (exhib. cat., Palazzo Tè, Mantua), Milan, 1994. (An attempt to evaluate the relationship of Mantegna's art to Alberti's treatises.)

A. Esch, "Mauern bei Mantegna," *Zeitschrift für Kunstgeschichte*, XLVII (1984): pp. 293-319. (A fascinating analysis of Mantegna's archaeological approach to architecture.)

G. Fiocco, *L'Arte di Andrea Mantegna*, Bologna, 1927, reprint, 1959. (A series of studies on various aspects of Mantegna's formation; it inspired an influential reply from Roberto Longhi that is at turns brilliant and perverse and has influenced many subsequent Italian writers.)

P. Kristeller, *Andrea Mantegna*, London and Leipzig, 1902. (The classic treatment of Mantegna, invaluble for its pre-war account of the frescoes in the Ovetari Chapel; the German edition contains appendices with documents and critical appraisals of Mantegna down to the time of Vasari. It should be noted that Kristeller's account of the Ovetari Chapel predates Rigoni's publication of documents fundamental to the authorship and date of the frescoes.)

R. Lightbown, *Mantegna*, Berkeley and Los Angeles, 1986. (A fine, completely reliable, if somewhat dry, account of Mantegna's work, with a balanced account of his fresco cycles in Padua and Mantua and a full catalogue raisonné that supercedes all earlier ones and makes citation of them superfluous.)

R. Longhi, "Lettera pittorica a Giuseppe Fiocco," in *Opere complete di Roberto Longhi*, II, Florence, 1967. (A reprint of Longhi's famous

open letter of 1926 blasting Fiocco's view of Mantegna; its influence on Italian critics is out of proportion to its real merits.)

M. Lucco, ed., *La pittura nel Veneto: Il Quattrocento*, Milan, 1990. (A good starting point for a general background; A. De Nicolò Salmazo's essay on Paduan art is excellent.)

A. Martindale, *The Triumphs of Caesar by Andrea Mantegna in the Collection of H. M. The Queen at Hampton Court*, London, 1979. (Although principally concerned with Mantegna's celebrated canvases of the Triumphs of Caesar, the study contains many observations pertinent to Mantegna's work in general: what the work lacks in elegance it makes up for in circumspect sagacity.)

J. Martineau, ed., *Andrea Mantegna*, London and New York, 1992. (Catalog to the exhibition held at the Royal Academy and the Metropolitan Museum of Art; it contains essays of varying quality addressing aspects of Mantegna's art.)

Mantova: La Storia, Le Arti, Le Lettere, Milan, 1961-62. (A multivolume publication that serves as a basic starting point for any student interested in the art and culture of the Gonzaga court.)

G. Romano, "Verso la maniera moderna: Da Mantegna a Raffaello," *Storia dell'arte italiana* 2, no. 2 (1981): pp. 5-85. (The most significant recent attempt to define Mantegna's place in the Renaissance.)

E. Tietze-Conrat, *Mantegna: Paintings, Drawings, Engravings*, London, 1955. (For a long time the most widely used short account in English on Mantegna. Its use is now marginal, and its catalog is completely superceded by that of Lightbown.)

J. Woods-Marsden, *The Gonzaga of Mantua and Pisanello's Arthurian Frescoes*, Princeton, 1987. (Concerned with the work of Pisanello, Mantegna's predecessor at Mantua, but of enormous use for an introduction to Gonzaga taste.)

The Ovetari Chapel:

Since their destruction in 1944 the frescoes have ceased to attract the attention they deserve. Moreover, when they are discussed, it is most frequently as isolated compositions. To my way of thinking, the importance of Squarcione for Mantegna's formation has been greatly exaggerated and that of Pizzolo undervalued, and this has skewed an understanding of the genesis of Mantegna's early style in the fresco cycle; see my essay in the 1992 *Andrea Mantegna* exhibition catalog.

S. Bettini and L. Puppi, *La Chiesa degli Eremitani di Padova*, Vicenza, 1970. (The basic reference book on the Eremitani, unfortunately written in dense Italian.)

B. Degenhart and A. Schmitt, "Jacopo Bellini und die Antike," in *Corpus der Italienischen Zeichnungen, 1300-1450: Jacopo Bellini*, 2, no. 5, (1990): pp. 192-213. (By far the most solid investigation of artists' uses of classical monuments in the Veneto at the moment of Mantegna's artistic formation; the information is directly relevant to the frescoes in the Ovetari Chapel.)

G. Fiocco, *The Frescoes of Mantegna in the Eremitani Church, Padua*, London, 1978. (A translation of Fiocco's book of 1947, written just three years after the destruction of the frescoes and reproducing them in color; unfortunately, printing standards were still primitive, and the reproductions are uniformly brown and muddy, giving only a vague idea of Mantegna as a colorist, for which the best point of reference remains his surviving work.)

P. D. Knabenshue, "Ancient and Medieval Elements in Mantegna's *Trial of St. James*," *Art Bulletin* 41 (1959): pp. 59-73. (Conjectures about possible sources used by Mantegna; I find most of them unconvincing.)

M. Muraro, "Francesco Squarcione 'umanista,'" in L. Grossato, ed., *Da Giotto al Mantegna*, Milan, 1974. (Muraro's essay, appearing in an exhibition catalogue, is the most ambitious estimate of Squarcione's position in Paduan art and the formation of Mantegna.)

A. de Nicolò Salmazo, *Il soggiorno padovano di Andrea Mantegna*, Padua, 1993. (The most recent review of Mantegna's early career in Padua; mainly concerned with issues of authorship and chronology.)

G. Paccagnini, in *Arte, pensiero e cultura a Mantova nel primo rinascimento in rapporto con la Toscana e con il Veneto: Atti del VI convegno Internazionale di Studi sul Rinascimento*, Florence, 1965, pp. 75-85. (A close reading of the documents relating to the Ovetari Chapel.)

E. Rigoni, *L'Arte rinascimentale in Padova*, 1970. (A reprint of Rigoni's study of 1927-28 publishing the documents on which all subsequent studies of the Ovetari Chapel are based.)

K. Shaw, *The Ovetari Chapel: Patronage, Attribution, and Chronology* (PhD diss., University of Pennsylvania), 1994. (The closest analysis of the documents related to the Ovetari Chapel, with a thoroughgoing attempt to relate them to the problems of attribution and chronology that have long vexed studies.)

A. M. Tamassia, "Visioni di antichità nell'opera del Mantegna," *Atti della Pontificia Accademia Romana di Archeologia, Rendiconti* 28 (1956): pp. 213-49. (The most extensive, if highly speculative and largely unconvincing, exploration of Mantegna's ancient sources.)

The Camera Picta:

The *Camera Picta* has been the focus of intense recent study, mostly related to the elaboration of a program. I find much of the recent bibliography unconvincing and cite only the most compelling or well-illustrated studies.

L. Coletti, *La Camera degli Sposi del Mantegna a Mantova*, Milan, 1959. (A good source for reproductions of the murals prior to the 1984-86 cleaning.)

M. Cordaro, ed., *Mantegna: The Camera degli Sposi*, Milan, 1992. (A lavishly produced book celebrating the cleaning campaign of 1984-86. It contains essays addressing various aspects of the work, of which the most important relate to the cleaning, which has made the works brighter but—alas—also cruder in appearance; compare to Coletti.)

A. Martindale, "Painting for Pleasure—Some Lost Fifteenth Century Secular Decorations of Northern Italy," in *The Vanishing Past: Studies of Medieval Art, Liturgy and Metrology Presented to Christopher Hohler*, 1981, pp. 109-31. (A fine overview examining pictorial cycles relevant to the *Camera Picta*.)

Quaderni di Palazzo Tè 6 (January-June 1987). (The issue is almost exclusively concerned with the *Camera Picta* and contains a good account of the technique Mantegna employed.)

R. Signorini, *Opus hoc tenue: La Camera Dipinta di Andrea Mantegna*, Mantua, 1985. (By far the richest treatment of the Gonzaga family in the years during which Mantegna was working on the *camera*: one does not have to agree with the interpretations of the room advanced to profit from the archival material Signorini has assembled.)

Glossary

Affresco (from the word for "fresh"; in English, "fresco"). Painting on freshly laid plaster with pigments dissolved in water. As plaster and paint dry together, they become united chemically. Known as "true" fresco (or "buon fresco"), but frequently used in combination with "secco" (see below) details, this technique was in general use for mural painting in Italy from the late thirteenth century on.

All'antica In the fifteenth century the expression was used to distinguish buildings employing the vocabulary of Roman architecture rather than the still prevalent Gothic style, which was called "modern." As is often the case with the terminology of art criticism, it appropriated a literary distinction between humanist style based on the example of Cicero and corrupt medieval Latin. Unquestionably, a value judgment was implied and not simply a distinction of style. The connection between architectural—and, in general, artistic—practice and literary style was explicitly made by the Florentine goldsmith-sculptor-architect Antonio Filarete in his treatise on architecture.

Arriccio (literally "rough"). The first layer of plaster spread on the masonry in preparation for painting; the "sinopia" (see below) is executed on this surface. It was purposely left rough so that the top layer (see "intonaco") would adhere to it more firmly.

Cartone (from the word for "heavy paper"; in English, "cartoon"). An enlarged version of the main lines of the final composition done on paper or cloth, sometimes, but not always, equal in size to the area to be painted. The cartoon was used to transfer the design to the wall; it could be divided in several sections for the creation of one large image. The cartoon was laid against the wall over the final layer of fresh plaster, so that outlines of the forms could be either incised with a stylus or transferred by "pouncing" (see "spolvero"). In either case, the outlines were used as guides for the artist to paint. The procedure was in common use by the second half of the fifteenth century, although it had been developed earlier.

Conversation portrait The term applies to group portraiture in which the sitters are shown as though engaged in a common activity or conversation rather than simply lined up. It reached its apogee in the eighteenth century.

Di sotto in sù (literally, from below, [looking] up). When a picture or sculpture is meant to be displayed above eye level and incorporates the consequent distortion of a low viewing/vanishing point, it has been conceived di sotto in sù. Perspective enables artists to determine the distortions mathematically rather than rely upon empirical foreshortening, but no artist neglected practical experience when the angle of vision was so steep as to make the image unrecognizable.

Giornata (from the word for "day"). The patch of "intonaco" to be painted "daily," not necessarily in one day. The artist decided in advance the size of the surface he would paint and laid on top of the "arriccio" or rough plaster only the amount of fresh "intonaco" or fine plaster needed for his work. The joinings usually are discernible upon a close examination of the painted surface, and they disclose the order in which the patches were painted because each successive patch slightly overlaps the preceding one.

Intonaco (literally "whitewash," or fine plaster). The final smooth layer of plaster on which painting with colors was carried out. Made from lime, fine sand, and marble dust and laid in sections (see "giornata").

Oculus Latin for "eye." The term applies to a circular opening or window molding. It is equivalent to the French term *oeil de boeuf* (bull's eye).

Pounce, pouncing Fine powder, usually pulverized charcoal, dusted over a stencil to transfer a design to an underlying surface.

Secco (literally "dry"). Painting on plaster that has already dried. The colors are mixed with an adhesive or binder to attach the color to the surface to be painted. The binding medium may be made from various substances, such as tempera. "Tempera" (pigment and animal or vegetable glue) or less often "tempera grassa" (pigment and egg) was commonly used to complete a composition already painted in fresco. Because the pigment and the dry wall surface do not become thoroughly united, as they do in true fresco, mural paintings done in tempera (or "a secco") tend to deteriorate and flake off the walls more rapidly.

Sinopia Originally a red ochre named after Sinope, a town on the Black Sea that was well known for its red pigments. In fresco technique the term was used for the final preparatory drawing on the "arriccio," which was normally executed in red ochre.

Spolvero (from the word for "dust"). An early method (see "cartone") of transferring the artist's drawing onto the "intonaco." After drawings as large as the frescoes were made on paper, their outlines were pricked, and the paper was cut into pieces the size of each day's work. After the day's patch of "intonaco" was laid, the corresponding drawing was placed over it and "dusted" with a cloth sack filled with charcoal powder, some of which passed through the tiny punctured holes to mark the design on the fresh "intonaco."